SARASOTA
A SENTIMENTAL JOURNEY

IN VINTAGE IMAGES

SARASOTA
A SENTIMENTAL JOURNEY

IN VINTAGE IMAGES

JEFF LAHURD

CHARLESTON · LONDON
History
PRESS

Published by The History Press
18 Percy Street
Charleston, SC 29403
866.223.5778
www.historypress.net

First edition originally published 1990
The History Press edition 2004

Manufactured in the United Kingdom

ISBN 1-59629-024-2

Library of Congress CIP data applied for.

Dedicated to my beautiful wife, Jennifer

This book was made possible through a grant from The Sarasota Alliance for Historic Preservation.

The author also wishes to thank the Downtown Kiwanis Club of Sarasota for sponsoring the first printing of this book and also the Sarasota County History Department for its contribution.

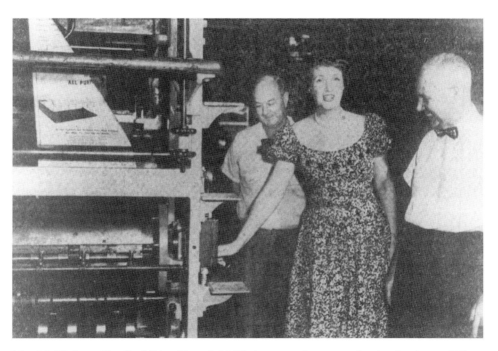

Mrs. McKinley, wife of publisher Kent S. McKinley, starts the presses for the first issue of *The News*, October 6, 1954. *The News* was located where the old Dude Ranch had been on Lime Ave. Publication ceased with the December 7, 1963 issue because of "severe economic losses." *The News*

Contents

Acknowledgements

I am grateful to all of those who helped me put this book together. There is a bond between long-time Sarasotans based on pleasant memories of life in a town that has all but disappeared. It was for these "old-timers" that *Sarasota, A Sentimental Journey: In Vintage Images*, and my first book, *Quintessential Sarasota*, were written.

In particular, I thank Nancy Wilke, former president of the Sarasota Alliance for Historic Preservation, who devoted a great deal of time and effort to the editing of this book. It reads much better thanks to her red pencil. Special thanks also go to Pete Esthus who accumulated so much information and memorabilia that for a long time his Sarasota Lock and Key shop on State Street was a museum of Sarasota's history. The late Lillian Burns, Sarasota's unofficial historian, who helped me so much with the first book that much of her effort spilled over into this one. John McCarthy, without whose initial guidance neither book would have been written. Wilson Stiles, former director of the Sarasota County Department of Historical Resources, and his staff, the late Robert "Uncle Bob" Viol, Charlotte Roberts and Ann Shank, who have made the resources of the archives available to me. For the reprinting of this book I owe a special debt of gratitude to the ever-patient Dan Hughes and also to Lorrie Muldowney, Mark Smith and Dave Baber, general manager of the Sarasota County History Center.

As this book is primarily a compilation of pictures and memories, I am grateful to those who were willing to share theirs with me: Mrs. J.C. Cash, Rudy Bundy, Max Frimberger, Susan Green Granger, Taylor Green, Frank Conrad, John Browning, Luther LeGette, Charles Morris, Christie Bussjaeger, Nello and Anne Marconi, Deputy Sergeant Bob Snell, Joan Dunklin, Sam Montgomery, Dave Chambers, Robert Kimbrough, Norton's Camera and Video, Mrs. B.D. Powell, Tom Bell, Stanley Marable, Peter Jahns, Lionel Murphy, Joan Griffith, John Moffett, Susan Roberts Granger, Millie Swope, Diane Esthus, Richard and Irene Roginski, Raymond Fernandez, Dr. Frank Evans, Jim Drymon, Benny Alvarez, Michael Garnett, Leonard Peeples, Carrol Dzina, Jack Plesus, Mary Namey, Linda and Gary Wisener.

I received information from *The News*, the *Sarasota Herald*, *This Week in Sarasota*, Roger Flory's *Visitors Guides*, the *Sarasota Journal*, the *Sarasota Times*, the *Sarasota Herald Tribune*, *The Story of Sarasota* by Karl H. Grismer, and *Sarasota Origins*, published by the Historical Society of Sarasota County.

Thank you to Dan Denton, Pam Daniel, Ilene Denton and Bryan Winke of Clubhouse Publishing Company and *Sarasota Magazine* for the initial publication of *Quintessential Sarasota*.

Warm appreciation and fond memories go to the late Abe Namey who was always there when my family and I needed him.

I am especially grateful to the Downtown Kiwanis Club, which financed the publication of the first edition of this book and to Kiwanis President Judge Andy Owens, Art Goldberg, and the Kiwanis Board of Directors who brought the club and book together. As one of the oldest service clubs in Sarasota, Kiwanis charter members were among those who were primarily responsible for Sarasota's initial growth and development.

Sadly, as this book was nearing completion, Nina Lewis, who helped me and so many others while she was at the county archives, died. Nina was one of those unsung heroes, unselfish in her generosity to others.

Introduction

A sentimental mystique surrounds yesteryear's Sarasota. Longtime residents speak wistfully of a small, beautiful, and relaxed town that somehow managed to slip away from them. They don't know how it happened, or precisely when, or even why, but they are disheartened that the Sarasota that evokes so many pleasant memories has all but disappeared. It has become their Camelot where the summers seemed cooler, the gulf and bay cleaner and greener, their neighbors friendlier.

In this Sarasota they walked downtown under a canopy of oak trees and greeted friends on each block. They remember their beaches as scenes from a brightly colored painting: long stretches of sugar-white sand accentuated with lush green foliage, palms and Australian pines. They strolled along in solitude as on a tropical island, occasionally passing a few shell collectors, bathers and sun worshippers basking among the sea oats. Gregarious beachgoers could find company at one of the multi-purpose pavilions and casinos—The Lido Pavilion, the Mira Mar Casino or Roberts' Pavilion in the 20s and 30s, the Lido Casino in the 40s, 50s and 60s—which offered dining, dancing, drinking, games and numerous social activities.

Parents did not have to cope with the myriad negative influences that have become familiar concerns for families in today's speeded up city. On Friday nights, their youngsters went to the Youth Center for dancing, ping-pong and board games. On Saturday they bicycled downtown to the movies, took the bus out to the beach or went fishing. Older siblings hung around the Smack, had orange fights at one of the groves, parked in the back row at the Trail or Siesta drive-in theaters, or partied on the deserted beaches. Beer was the usual contraband of choice, and while parents were concerned about teenage drinking, drugs were virtually unheard of.

There was a genuine sense among yesteryear's Sarasotans that they were more than just residents of a place called Sarasota, they were Sarasotans—and proud of it. How could they not be? Their community was blessed with magnificent weather and unparalleled beauty, it was heralded everywhere as the Circus City, it perennially attracted the rich and famous from around the world and it had as permanent residents artists, writers, performers, sports figures and renowned retirees. It is astounding that such a very small town—the population of the city was less than 25,000 until 1954, and the county population did not reach 75,000 until 1960—could offer so much to so few. The city offered magnificent bayfront mansions, grand hotels such as the Mira Mar, El Vernona and Sarasota Terrace; numerous tourist attractions—the most notable being the elaborate winter quarters of the Ringling Brothers and Barnum and Bailey Circus—and unsurpassed cultural achievements, the hallmark of which was and still is the Ringling Art Museum.

Only bits and pieces of the romanticized Sarasota have managed to survive into the 2000s. In the early 50s, as we strove to modernize, and attract more residents, light industry and summer tourists, the very places that gave Sarasota its unique ambiance began to be sacrificed in the name of progress. Indeed, one of the very first casualties, the removal of the memorial oak trees along Main Street was billed in *The News* as the battle between sentiment and progress with one of our city commissioners assuring that we could not have both. Another striking change occurred when highway US 41 was rerouted, cutting a large swath through beautiful Luke Wood Park and alongside Gulfstream Avenue, effectively isolating the bay front from downtown, ruining what had been a peaceful and charming drive along the water's edge.

By the end of the decade, the old Ringling Bridge—home away from home for countless fishermen—had been replaced with the new four lane version; the circus abandoned its world-famous Winter Quarters and moved to Venice, and Arvida Corporation would soon begin its massive plan to develop the keys.

Large-scale housing projects were resumed on the mainland after having come to a virtual standstill after the real estate bust of the late 1920s. At the beginning of the 1950s, Sarasota began to spread out to what had been the "sticks" and the orange groves. Concurrently, shopping malls, strip centers, schools, movie houses, offices and various other stores were built to accommodate the newcomers, and downtown, once the center of Sarasota's universe, fell on hard times.

In 1962, the old Colonial Hotel, which had served tourists as the Watrous since 1916, was demolished, and in 1965 the entire south side of lower Main Street from Pineapple to Palm was bulldozed for downtown parking. In the rubble was one of Sarasota's favorite businesses, Badger's Drugs—"The Store of the Town." By the end of the 1960s, two of our most famous buildings, the old Hover Arcade at the foot of lower Main Street since 1913, and the universally loved (and missed) Lido Casino, our beach hallmark since 1940, were razed as was the Ritz Theatre, built as the Virginian in 1916.

By 1970, so much had been lost that new arrivals came to a Sarasota, which had precious little remaining of its idyllic past. The Mediterranean/Spanish Mission-style architecture, which had been prevalent throughout the community, made way for the modern look that could be found in any city in America. The major buildings, which had not been demolished—the Palmer Bank, The Sarasota Hotel and the Orange Blossom Hotel—were remodeled to the point of being unrecognizable. The atmosphere of the beaches shifted from tropical paradise where artists and writers strolled for inspiration to overly developed platforms laden with multi-storied condominiums.

Obviously, the virtues of modern Sarasota are many and varied, and thousands of new residents and visitors are drawn here each year to a beautiful, cultured, "with it" city.

When old timers reflect back on what Sarasota once was, however—as often they do—they may be forgiven for believing that today's Sarasota would be so much the better if more attention were paid to preserving its past. This is, after all, their paradise lost.

ROARING THROUGH THE TWENTIES

On New Year's Eve, 1919, 154 of Sarasota's "most beautiful femininity and handsomest masculine element" gathered for a celebration at the clubhouse of the Golf Holding Company. When the gong sounded midnight, the lamps were extinguished and a beautiful panel of colored lights containing the figures "1920" slowly lighted.

The ball was said to have been one of the most successful functions ever held here and the celebrants must have been pleased the next day when they read in the *Sarasota Times*, "the soft glow of the lights, augmented by the bright moon's rays . . . as they danced . . . made a picture worthy of a master hand."

None of the revelers, not even the most optimistic of Sarasota's boosters, could have had a clue that the new decade would foster a real estate and building spree that would transform their village into such a desirable winter resort for the rich and famous. The quiet town with promise was set to roar through the 20s with the rest of the nation. And while it shared the frivolous elements of the Jazz Age—the hooch, the wild music and dances, the bobbed-haired flappers and slick-haired sheiks—it augmented the Age of Bally Hoo with the accoutrements that would make Sarasota an idyllic place to live and visit and set the foundation for today's modern city.

Foremost on the wish list of the *Times* New Year's Day edition was a modern hotel. Sarasota, it noted, had "the nucleus for one of the best tourist resorts in the state" but there was no suitable lodging. The Belle Haven Inn (Desoto Hotel) on the corner of Main Street and Palm Avenue was antiquated and did not appeal to the caliber of guest we sought, nor did the Watrous (Colonial) across the street. The paper beseeched, "We much dream big things, and then work to make our dreams come true." This big dream for a world-class

hotel was realized when Andrew McAnsh, "town builder," (he was literally met by a brass band) constructed the Mediterranean-style Mira Mar Apartments, Hotel and Auditorium—a prelude for what was soon to come. The ensuing real estate boom struck like a lightning bolt. Everywhere one looked, Sarasota was prospering. Growth that would have ordinarily taken decades to achieve was accomplished in a few halcyon years. From 1923 through 1926, most of the Sarasota that we reminisce about today blossomed forth. Starting with the Mira Mar complex on Palm Avenue and McAnsh Boulevard, construction roared on producing the Hotel Sarasota, American National Bank (Orange Blossom), First Bank and Trust (Palmer Bank, Southeast Bank), the Ringling Causeway, Ringling Isles, the *Sarasota Herald* building (Sarasota Woman's Exchange), Sarasota Terrace Hotel (County Administration Building), El Vernona Hotel (John Ringling Hotel/Ringling Towers, razed in 1998), El Vernona Apartments (Broadway Apartments), Lord's Arcade, Cummer Arcade, Burns Court, Herald Square, Edwards Theater (Florida Theater/Sarasota Opera House), Mira Mar Casino, Roberts Pavilion, Atlantic Coastline railway station, Kathadin Court Apartments, Stickney Point Bridge, Siesta Key Bridge, Sarasota County Courthouse, Bay Haven Hotel (Ringling School of Art and Design), the Ringling Art Museum and a wealth of small apartment houses, fine homes and fabulous mansions.

The newspapers, the *Sarasota Times*, the *Sarasota Herald* and *This Week in Sarasota*, kept the electricity flowing with flowery headlines of each new happening: "Causeway Is Proof Of John Ringling's Courage," "Sarasota's New Buildings Give Prosperity Visibility" and "Hotel El Vernona Most Distinctive In United States." Real estate speculation was fueled by fantastic one- and two-full-page ads promising easy money: "Price Climbing, let your profits go up with the climb," "Values are constantly enhancing" and "An Opportunity for Big Profit." And if the boisterous ads were not convincing enough, the "Knickerbocker army" of real estate agents swarming throughout the city in their knickers could fast talk even the meek into taking a flyer on "a sure thing." The staff of A.S. Skinner, agents for Longboat Shores and Golden Gate Point, grew from 3 to 66 men by the end of 1925 and bragged that Golden Gate Point had "sold out some time ago [and] some lots have been sold seven times." The Skinner organization laid claim to $40,000,000 in business during the year, and *The Sarasota Herald* reported an increase in real estate sales of 1,000 percent over 1924. *This Week in Sarasota* boasted, "Sarasota Established New World's Record for Cities of 10,000 Population, with Program of $33,000,000 in Assured Projects for 1925." Reflecting the spectacular increases was the very active chamber of commerce, which grew from 125 to 2,000 numbers in a single year.

A wide array of entertainment became available. Those not caught up in the freewheeling shenanigans of the Sheiks and Shebas could listen to the "charming music" of Dale Troy's Orchestra featuring "Happy Bill" Cope, banjo player and singer. The Mira Mar Auditorium offered diverse acts. Frieda Hempel, "The Jenny Lind of Today," warmed audiences with her lovely voice and provided "all the atmosphere of bygone days." Lowell Thomas enthralled a full house with his famous lecture, "With Lawrence in Arabia and Allenby in Palestine." Will Rogers "Mayor of Beverly Hills," performed at the Edwards Theater, which also offered such fare as Irving Berlin's *Music Box Revue*, "125 people, 7 carloads of scenery, and the Famous French Imported Beauty Chorus of 60." Down the street, the Airdome hosted the Vaudeville Revue with the Dolly Dimple Girls, "a pretty and preppy chorus." Season-long performances were given by the City Municipal Band under the direction of Merle Evans and then Voltaire Sturgis. The Czecho-Slovakian band was enormously popular, as were Sarasota's Minstrels.

Movie houses screened Hollywood's latest offerings: scintillating flicks starring the girl with plenty of "IT," Clara Bow, in *The Fleets In*, followed by Pola Negri, "Mistress of Moods, Lady of Love, Radiant Regent of Romance" in *Flower of Night*. A real shocker, *Is Your Daughter Safe?* was so daring that separate screenings were held for men and women.

Those given to the new dance crazes could "Hey! Hey! Hey! Shake It Again" to the "rousing good" Tennessee Serenaders or Van Orden's Sarasotans, Pfeiffer's Melody Kings, Bud Rice's Kentucky Night Hawks or one of the myriad of other one-niters who breezed through town keeping everything "hotsy totsy."

Other diversions included snooker and billiards at one of the newly opened pool halls, which soon came under the scrutiny of the city council. Chief Davis was ordered to close them and the "near beer" saloons at midnight because of "rowdyism and boisterous conduct."

The fight against demon rum and the vicissitudes of gambling were forever being waged by "right thinking" citizens throughout this carefree decade, but while lovely Frieda was melting hearts with her angelic voice for the benefit of the Young Women's Christian Association, upstairs a Chicago concern was running a gambling room for millionaire "snowbirds" and paying off winners with silver dollars. Prohibition was a losing proposition. A grand jury alleged that liquor traffic in Sarasota was protected.

Sportsmen were treated to an array of opportunities. Gulf and bay fishing was unequalled, and the woods provided plenty of game for hunters. The New York Giants began to train here in 1924 and practiced for three seasons until their great manager, John J. McGraw, "Little Napoleon," fell in the real estate debacle with the failure of his Pennant Park subdivision located just north of Whitfield Estates. A traveling sports writer told readers why the Giants were not in first place: "McGraw stands to loose two millions . . . you can't play baseball and be a financier."

The Sarasota Yacht Club sponsored sailing and motor regattas with "scores of the fastest boats in the nation entered." In 1927, our own *Sara-de-Sota* was favored, having won the gold cup race in Tampa the previous week.

Even the incomparable Jim Thorpe came to Sarasota with his "band of braves" and played the Sarasota Collegians. As the *Herald* quipped, "A more colorful array of players never graced the local gridiron than those which the Indian will bring here." The Czecho-Slovakian Band was on hand to provide half-time entertainment.

For those who preferred to view the action from the comfort of their Morris chair, the newspapers offered excitement galore. Interspersed with articles about the local progress were tabloid-like accounts of the madcap goings-on around the nation and the world. Daily box scores in the battle between the bootleggers and the feds—"Federal Raid Results In 7 Stills Seized. 15 Officers Arrested," juicy divorces, "Peaches Will Be Confronted By Boy Friends," sensational crime sprees, "Condemned Men Escape Prison And Terrorize Illinois. Faced By Death They Break For Liberty Again," feats of daring, "Bill Perry Proves Hero At the Beach." A full page was devoted to pseudoscientific glimpses into the future: "A Sky and Water Ship That Hops Across The Ocean," complete with artist rendering; tales of wild romances and schemes, "How the Clown Won Back the Beauty . . .Tale of the Spirited Love Duel Between Ray Dean, Late Monarch of the South Seas, and Pepito the Buffoon," with pictures of the trio, Pepito in his clown's outfit; "Why Iron Mike Became Miss Fluffy Ruffels," he became a female impersonator because he could not make a living driving a truck.

All of the principal players of this exciting era of Sarasota's birth, growth and change are now gone. The city that was fashioned around their dreams and built through their determination has been diminished over the years. The little that remains of their legacy— their homes and buildings—must be protected and preserved. When it is asked someday, "Where is the John Ringling Towers," the answer must not be, "It's that big parking lot south of the Quay." (The John Ringling Towers was demolished in 1998 despite an heroic attempt by the John Ringling Centre Foundation, the Sarasota Alliance for Historic Preservation and many concerned citizens to save it.)

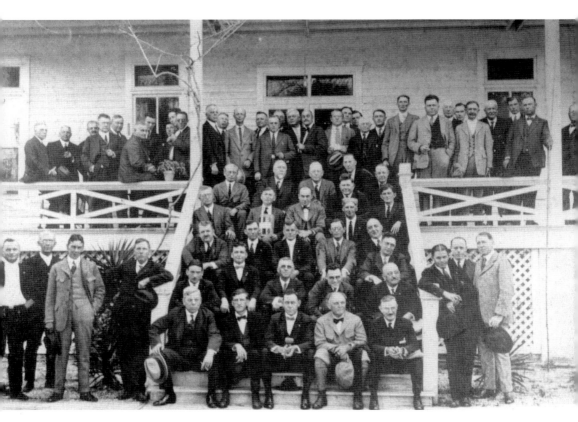

On November 11, 1922—Armistice Day—a group of men gathered at the Memorial Flag Pole at the center of Five Points. They were attired in white pants, white shirts, dark ties and straw hats to present themselves to the community as the newly formed Kiwanis Club. Sarasota was only moments away from the biggest real estate and building boom in its history when the club was chartered. Among the members of this group were the men who would make it all happen and thrust Sarasota from a fishing village to a renowned winter resort, thereby sowing the seeds for today's modern city. This picture of the newly chartered Kiwanis Club was taken at the Bay Island Hotel in the winter of 1923.

Standing on the ground left to right: Dr. F.W. Schultz, Professor R.W. Yarborough, F.H. Gallup, A.B. Edwards, Judge Paul Albritton, Judge Arthur Clark, Tom Ragland. On bottom step left to right: Ralph C. Caples, Mike Roth, A.L. Joyner, (President), U.S. Congressman Knight (guest), Ernest Booth. Second row: Frank C. Martin, Unknown, T.L. Livermore, Harbert S. Sawyer, Unknown. Third row: Dr. W.J. (Happy) Johnston, E.J. Battle, Unknown, Frank A. Walpole, W.A. Smith, Dr. Joe Halton sitting in front of E.A. Smith. Fourth row: Harry Sawyer, Phil Levy, A.S. Skinner, W.L. (Bill) Pearsall, Fred West. Standing on porch: Lewis Cadwell, L.C. Strong, Unknown, Dr. Jack Halton, R.K. Thompson, Spencer (Spen) Olson, Unknown, Owen Burns, Paul Thompson, Clarence E. Hitchings, Franklin P. Dean, Ernie Burch, Stanley Longmire, Barnet Curry, Unknown, Unknown, Oscar O. Ellis, J.O. Gardner, Ed Cowles, J.H. Lord, Velma Keen, Col. J.B. Fletcher, Jo Gill Sr., C.O. Teate Sr., Unknown, Unknown, Unknown, Unknown, Col. J. Hamilton Gillespie, W.K. Wolfe, E.O. (Ed) Burns, Unknown. *Sarasota County History Department*

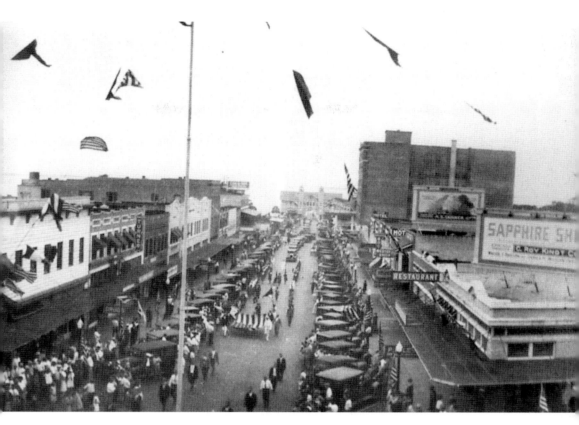

Lower Main Street, 1925: The tall building to the right is the red brick Sarasota Hotel, our first skyscraper. Built by W.H. Pipcorn for a reported $250,000, it was the first building to have an electric elevator and Mr. Pipcorn was the first person to pay $1,000 for a front foot of downtown property. The hotel catered to "both commercial and tourist patronage whose every comfort we contemplate." At the end of the street is the Hover Arcade building, the site of our city hall for many years. To left of city hall, the old Belle Haven Hotel had been demolished and soon the American National Bank would rise, ultimately to become the Orange Blossom Hotel. Turner's, to the left of the flag pole, "Home of Quality Merchandise," sold Jantzen swimwear, "The suit that changed bathing to swimming." As one ad put it, "Casually she pauses in her smart, trim Jantzen—welcoming coyly the appraisal of flattering eyes." Across the street in the Cummer Building is Levy's, "The Store that Satisfies," now known to most of us as the site of the Sport Shop. Nearby, Martin's Sweet Shop offered curb service and advertised that men left home "to get that cool, delicious drink at Martin's." *Sarasota County History Center*

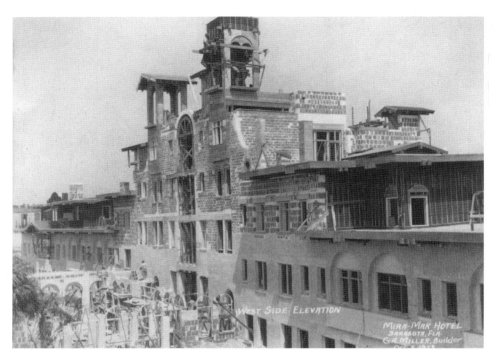

Signs of Sarasota's new prosperity were everywhere to be seen during the mid–twenties. New hotels, apartment houses, banks, theaters, schools and housing developments sprang up throughout the city. Under construction here the Mira Mar Hotel, Sarasota's "Palatial Hostelery."

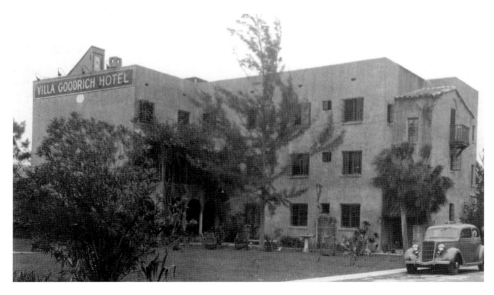

Villa Goodrich Hotel on Goodrich Ave. Villa Goodrich "caters to that large class of refined winter visitors who wish relief from the constant social whirl of larger and more expensive hotels."

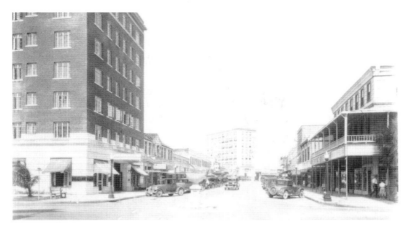

Looking up lower Main Street toward Five Points and the First Bank and Trust Company, which opened in 1925, boasting capital and surplus of over $200,000. It proclaimed: "The Big Bank At Five Points that carries the Five Points of Success: Reliability, Efficiency, Courtesy, Resources, Personal Services." Later this would be the site of the Palmer Bank, which opened on July 20, 1929. It was managed for many years by Benton W. Powell who joined the Palmer organization in 1926. Mr. Powell also published the *Sarasota Tribune* from 1934 to 1938. The Hotel Watrous and Sarasota Hotel are to the left. Farther up the street, the Little Hotel offered rooms for $1.00 per night. *Sarasota County History Center*

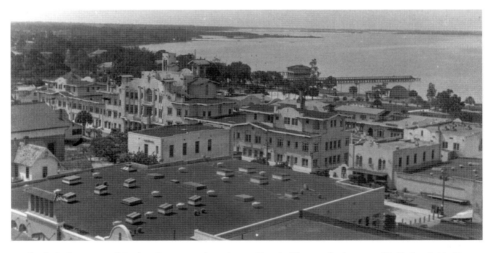

In the left foreground is the Cummer Arcade on South Pineapple Avenue. Built by A.E. Cummer, president of Asphalt Machinery Company of Cleveland, whose equipment was responsible for Sarasota's first asphalt streets. Sarasota's first modern post office was housed here as well as 11 other stores and shops. Further left is the First Methodist Church, which was erected in 1914. To the rear of the church is the Mira Mar Hotel. To the right of the train spur, which juts out into Sarasota Bay is a band shell that was built in 1924 with "funds raised by public subscription of $50 each, started by John Ringling, capitalist . . . Ralph Caples and others as a matter of civic pride. Uniforms for the Sarasota Municipal Band were donated by Andrew McAnsh, the Chicago Capitalist." To the right of the Mira Mar is the DeMarcay's Hotel, "The Best Equipped Hotel and Cafe in South Florida." *Sarasota County History Center*

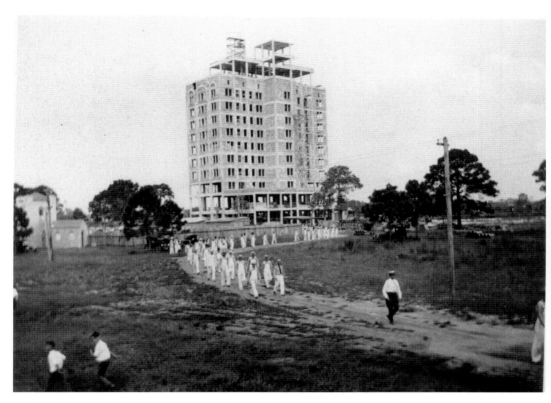

Strikers temporarily halt work on Charles Ringling's Sarasota Terrace Hotel. The 125-room hostelry advertised that it was "Near Enough In To Be Convenient . . . Far Enough Out To Be Pleasant." The hotel was the hallmark of Ringling's Courthouse subdivision and is still an imposing sight as the County Administration Building. The hotel changed hands numerous times over the years. Boston Red Sox and Chicago White Sox players stayed at the hotel during spring training. In 1925, Local Union #1383 boasted 500 union carpenters and joiners, and wages that year were increased from $.85 to $1.00 per hour. Charles Ringling was one of Sarasota's greatest boosters and business leaders. It is for him that Ringling Boulevard was named. He died in 1926 after a brief illness. *Sarasota County History Center*

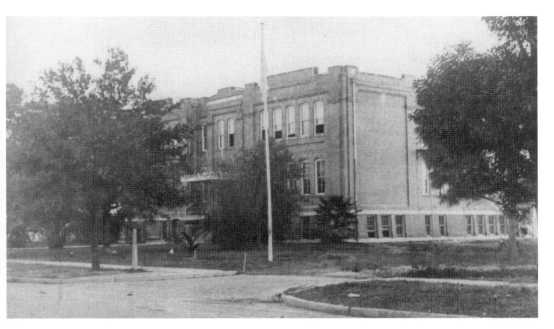

Sarasota's first brick high school was located on Main Street, just east of Orange Avenue. Completed in 1914, its first graduating class in 1915 consisted of four young women. When the building was demolished in 1958, many of its bricks were used for the walkways and a few of the buildings at Sarasota Jungle Gardens. *Sarasota County History Center*

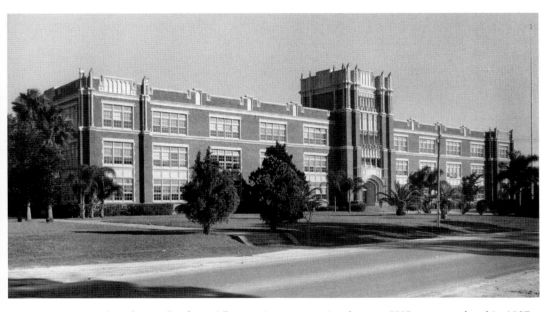

To accommodate the needs of a rapidly growing community, the new SHS was completed in 1927, and offered extracurricular activities: a storytelling club, hiking club, and uke club. The year book reflected the optimism of the era; "To the Spirit of Sarasota, We dedicated this log; Hoping never a fog may veil the Port of Progress." *Sarasota County History Center*

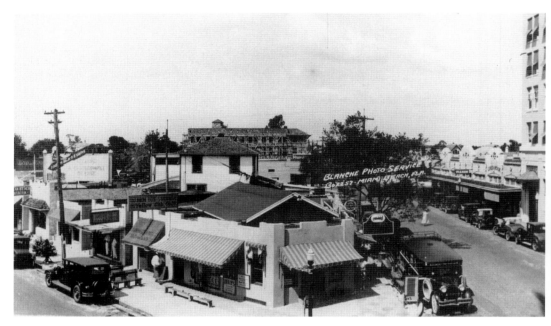

North Pineapple Avenue is to the left and Central Avenue is to the right in this photo taken from the center of Five Points. The Union Bus Station has been the site of many businesses over the years and in 1990, the site became the location of a city park. On Central Avenue is the Commercial Court Building, one of Sarasota's first professional buildings. It was the home of the Commercial Insurance Agency and also housed 55 offices and 11 stores "particularly adapted to Sarasota's delightful climate." *Charles Morris*

Owen Burns was one of the principal figures in the modernization and development of Sarasota. He came here in 1910, bought the extensive holdings of J.H. Gillespie and began the task of changing the fishing village appearance of the community. He helped to set the stage for the boom era of the 1920s by cleaning up the bay front, building sea walls around the basin and making many improvements, which beautified the city. His buildings are among the finest and most beautiful ever constructed in Sarasota. They include the El Vernona Hotel (demolished as the John Ringling Towers in 1998), Broadway Apartments, Burns Court and Herald Square. Karl Grismer in *The Story of Sarasota* said of him, "Without question, he must be recorded in history as Sarasota's first outstanding developer." *Lillian Burns*

Right and below:
Stretching to Ringling Isles form a recently dredged Golden Gate Point, the Ringling Causeway is partially complete in this 1925 photo. The bascule portion of the bridge was electrically operated and could be raised and lowered in 40 to 60 seconds. At 26 feet wide, the bridge was said to be the widest of its type in Florida. As Ringling was away much of the time, Owen Burns, vice president of Ringling Estates, Inc., supervised the construction of the bridge and the development of Lido and St. Armands Keys. *Sarasota County History Department.*

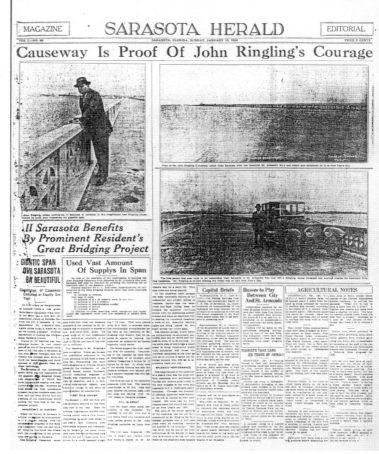

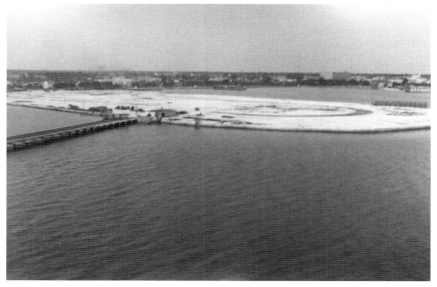

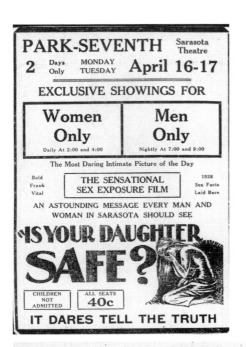

PARK-SEVENTH Sarasota Theatre

2 Days Only MONDAY TUESDAY **April 16-17**

EXCLUSIVE SHOWINGS FOR

Women Only	Men Only
Daily At 2:00 and 4:00	Nightly At 7:00 and 9:00

The Most Daring Intimate Picture of the Day

Bold Frank Vital **THE SENSATIONAL SEX EXPOSURE FILM** 1928 Sex Facts Laid Bare

AN ASTOUNDING MESSAGE EVERY MAN AND WOMAN IN SARASOTA SHOULD SEE

"IS YOUR DAUGHTER SAFE?"

CHILDREN NOT ADMITTED	ALL SEATS **40c**

IT DARES TELL THE TRUTH

SARASOTA Theatre

Tuesday Wednesday

Recreation for Ladies

Exercise for Men

Here in our billiard rooms will be found the opportunity for recreation for women. These games will provide them with exercise that will keep them youthful and add grace to their carriage.

Women will have no hesitancy in visiting our room, so wholesome is the atmosphere. The courteous, intelligent service will please them.

Feeling sluggish, tired and a bit run-down? You need exercise. A short time each day spent in our billiard room will lend zest to your every action, will stimulate you mentally and physically.. These fascinating games are the ounce of prevention that keeps the doctor away.

It is a pleasure to play on our equipment— made by Brunswick. The surroundings are wholesome and conducive to quiet enjoyment of these games.

SAN JUAN BILLIARD HALL
209 SIXTH STREET

This page and opposite above: A sampling of advertisements from the age of Ballyhoo.

How Far Will A Girl Go?

—in accepting the admiration of another girl's man? Was Emily Andrews right in thinking that all is fair in love?

READ

"SWEETHEARTS"
By IDAH McGLONE GIBSON

Starts Today
Turn Now to Page 9

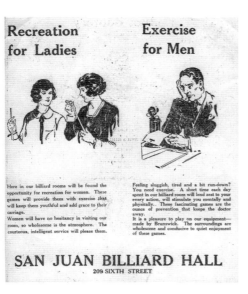

Recreation for Ladies | Exercise for Men

Here in our billiard rooms will be found the opportunity for recreation for women. These games will provide them with exercise that will keep them youthful and add grace to their carriage.

Women will have no hesitancy in visiting our room, so wholesome is the atmosphere. The courteous, intelligent service will please them.

Feeling sluggish, tired and a bit run-down? You need exercise. A short time each day spent in our billiard room will lend zest to your every action, will stimulate you mentally and physically. These fascinating games are the ounce of prevention that keeps the doctor away.

It is a pleasure to play on our equipment—made by Brunswick. The surroundings are wholesome and conducive to quiet enjoyment of these games.

SAN JUAN BILLIARD HALL
209 SIXTH STREET

A Becoming "Bob" For Every Type

Afraid to have your hair cut? You need not be. Our experts can determine from the size, shape and type of your face the "bob" that will become your style of beauty.

Sarasota Beauty Shop
Mr. W. M. Smith
In Charge of Bobbing

McAnsh Square
Mira-Mar Bldg

Phone 6942

Below right: During the 20s, the American Tobacco Co. ran a series of endorsements touting the benefits of smoking Lucky Strikes. Actors, sports figures, and band leaders bragged about the benefits of smoking. Tennis champ, William T. Tilden, said he smoked to protect his throat. In the 1930s, Philip Morris sponsored a nationwide lecture tour demonstrating for women the proper etiquette of cigarette smoking, covering such important topics as holding a cigarette without looking affected.

WRESTLING EXHIBITION

TONIGHT
Race Track, Old Fair Grounds
Beginning 8:30 P. M.

— LADIES FREE —

MAIN EVENT

Silent Olsen
Sweedish Heavy-weight
190 Lbs.
VS
Dr. Bobby Main-fort
—American—
190 Lbs.

Seminal-Final

Young Hartc
"German
Heavyweight"
190 Lbs.
VS
Peter Mommos
180 Lbs.
"Greek Champ"

PRELIMINARY

Rough House
Nelson
VS
Walt Evans

"Silent Olsen"
Seats Now On Sale "Gem Cafe"

—PRICES—

$1.10 —:— $2.20 —:— $3.30

"I Always Have Luckies" says Betty Compson, Motion Picture Star

"The strain of constant posing before a camera is sometimes great. A few puffs from a good cigarette is the quickest relief. I always have Luckies on the set. They soothe without the slightest throat irritation."

Betty Compson.

LUCKY STRIKE
IT'S TOASTED
CIGARETTES

The Cream of the Tobacco Crop

"Unquestionably Lucky Strike Cigarettes are 100% quality as this fact is proven by their increasing popularity. Only the best tobacco, 'The Cream of the Crop' goes into Lucky Strike Cigarettes. I buy only the best tobacco for Lucky Strike Cigarettes."

W. A. Gruntage

"It's toasted"
No Throat Irritation-No Cough.

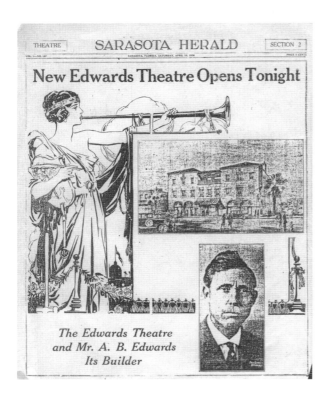

Above and below: Construction underway on the Edwards Theater, which opened in 1926. Opening night entertainment included the Czecho-Slovakian National Band, the theater's orchestra, with a vocal solo by Louise Philips, daughter of A.B. Edwards, the theater's builder/owner. The Mediterranean Revival-style building was designed by Roy A. Benjamin to accommodate silent movies, vaudeville acts and opera. It housed offices, bachelor apartments and cost $350,000 to construct. A.B. Edwards, a native of the Sarasota area, was prominent in business circles. In 1913, when the town of Sarasota voted to become a city effective January 1, 1914, Edwards was elected to become the city's first mayor. The theater's name was changed to the Florida Theater in 1936.

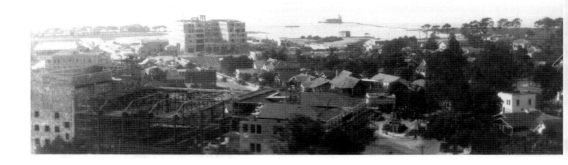

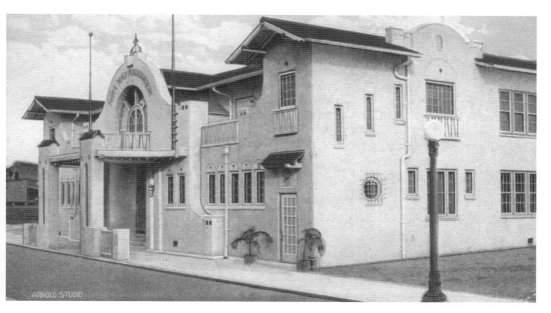

Post Card Week was a state-wide effort to advertise Florida. A gold cup was awarded by the Florida Development Board to the town that mailed out the largest number of cards. This card shows the Mira Mar Auditorium on McAnsh Boulevard. It opened on January 19, 1924, as "The Event of the Season." Entertainment was provided by Josephine Lucchese (coloratura soprano), Robert Ringling (baritone) and Margaret Carlisle. Ms. Lucchese was an understudy for Helen Morgan. The auditorium would become one of Sarasota's most popular gathering places. It was demolished in 1955. *Sarasota County History Center*

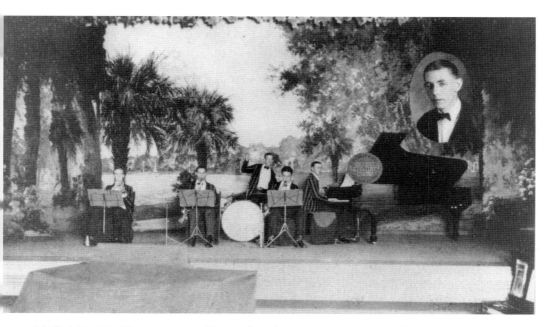

Pfeiffer's Melody Kings was one of Sarasota's earliest jazz groups. *Sarasota County History Center*

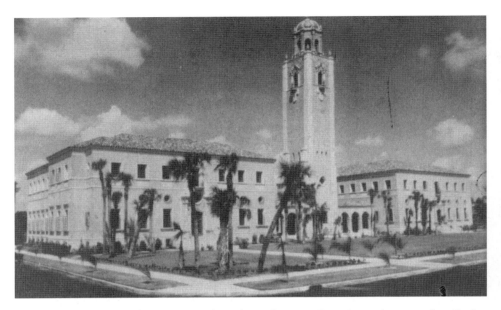

The Sarasota County Courthouse, another of Dwight James Baum's creations, was described in *Florida in the Making*, as "the most beautiful building south of Washington D.C." The Palmer interests had wanted Venice to be the county seat and offered a site and a large donation for the building. *Sarasota County History Center*

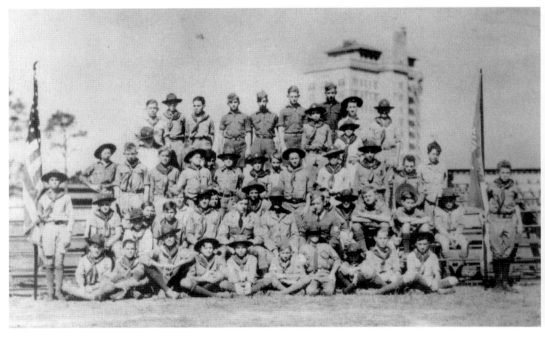

The Boy Scouts, one of Sarasota's oldest organized groups, was formed in 1913 for "the moral training and development of the boys." One of their earliest duties included making reports on the sanitary conditions of the city, "taking in all the streets and alleys." *Pete Esthus*

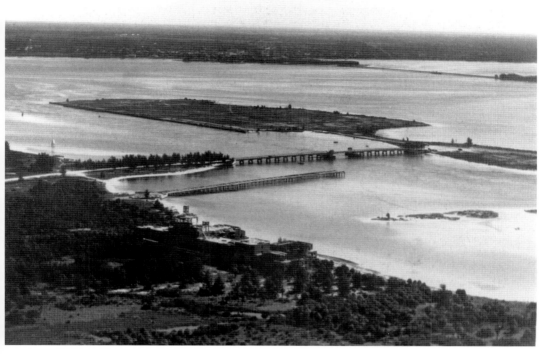

A deep-water port was one of Sarasota's "must have" items during the boom-time 20s. The resulting dredge was used to create City Island. *Pete Esthus*

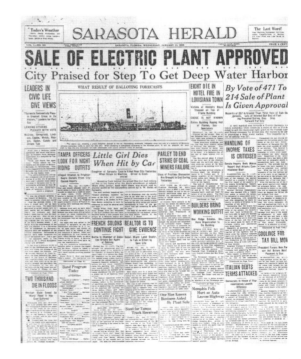

Full-page ads touted the importance of a harbor for Sarasota's continued growth. To finance the project, the city's electric plant was sold for $1 million. *Pete Esthus*

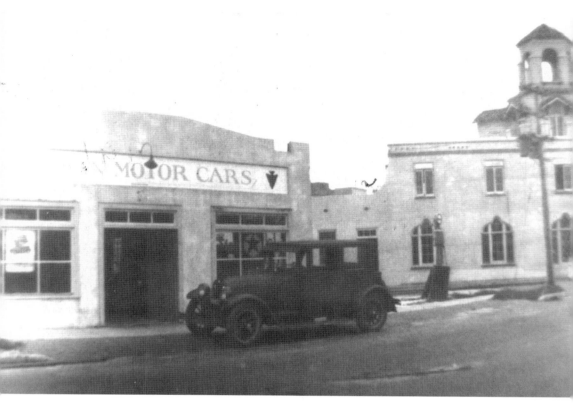

If any car personified the Great Gatsby lifestyle of the Roaring 20s, it was the Jordan Speedster. Its manufacturer, Ned Jordan, began a series of advertisements, which were said to have brought him more fame than the car itself. One of the most popular of these went, "Somewhere west of Laramie there's a bronco-busting, steer roping girl who knows what I'm talking about . . . The truth is—the Playboy was built for her. Built for the lass whose face is brown with the sun when the day is done of revel and romp and race." This dealership was located near the northwest corner of Pineapple and Strawberry Avenues. After producing such models as the Playboy, Tomboy, Blueboy and a special order, Speedway Ace, Jordan quit production in 1931. The building to the right is the plant for *This Week In Sarasota*, a popular weekly publication during the 20s. The paper was owned by J.V. Moore and Robert Dooley, and its editor was Edward Cowles. On January 8, 1925, it proudly announced, "Sarasota Establishes New World's Record for Cities of 10,000 Population with Program of $33,000,000 in Assured Projects for 1925." It went on: "The aggregate of this stupendous program for Sarasota County in the next twelve months [defies] every city in America . . . with but two exceptions, New York City and Chicago." In the 1950s, this was the home of the Veterans of Foreign Wars. During the late 30s, through the war years, it was the very popular Casa Madrid. *Charles Morris*

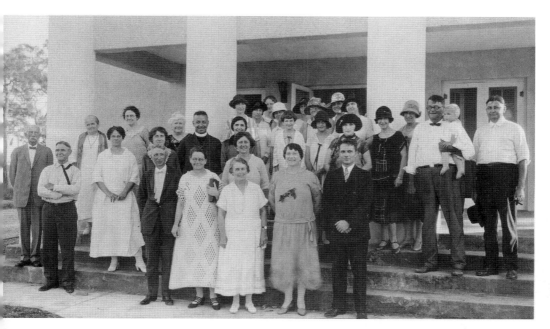

Dedication at the opening of Sarasota Hospital, Hawthorne Street, 1925. Thomas Reed Martin and Frank C. Martin, architect; Logan & Curin, contractors; George L. Thacker, building chairman; Mrs. E.A. Smith, Mrs. George B. Prime and Paul Noble, finance committee; Mrs. Ruth Wilhelm, first superintendent of hospital and nurses. *Christie Bussjaeger*

Staff members in front of the original *Sarasota Herald* building when it was located on Orange Avenue near Little Five Points. Founded by George D. Lindsay, his son, David B. Lindsay, Paul Poynter and Edward E. Naugle, the first edition rolled off the press on October 4, 1925, with the headline: "SENATOR FLETCHER HURT IN CRASH." The first editorial explained the newspaper's policy: "in a single word—service." Today it is the site of the Woman's Exchange. *Sarasota County History Center*

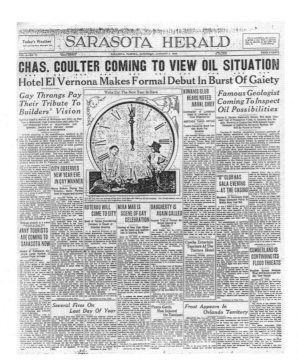

The *Sarasota Herald* announces the start of an expected oil boom. *Sarasota County History Center*

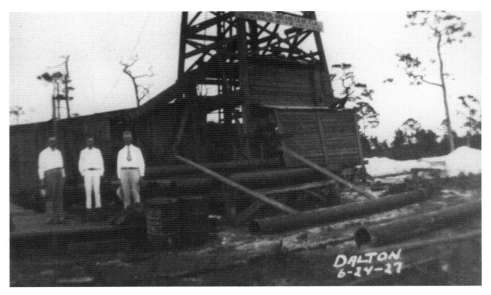

Associated Oil and Gas derrick located on the Ringling tract twelve miles east of Englewood. The "spudding in" ceremony was held on March 13, 1927, and Roger Hornsby, "ball player deluxe," officially started the show. The quest for black gold came during the real estate bust and a company spokesman promised that "should oil be found, and we are certain that it will, the first so-called boom will be as a gentle zephyr by comparison." Free cigars for men and free candy and soft drinks for women and children were offered to the onlookers. The only thing that flowed from the well was sulphur water. *Sarasota County History Center*

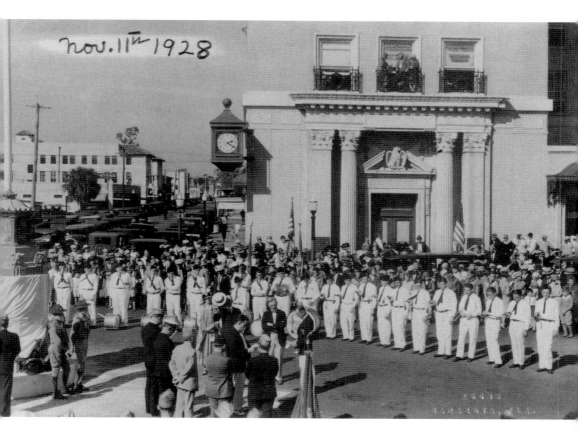

Dedication of the American Legion War Memorial in the center of Five Points. A Sarasota "old timer" may be defined as anyone who lived in town before the landmark memorial was moved to Gulfstream Avenue in 1954. *Sarasota County History Center*

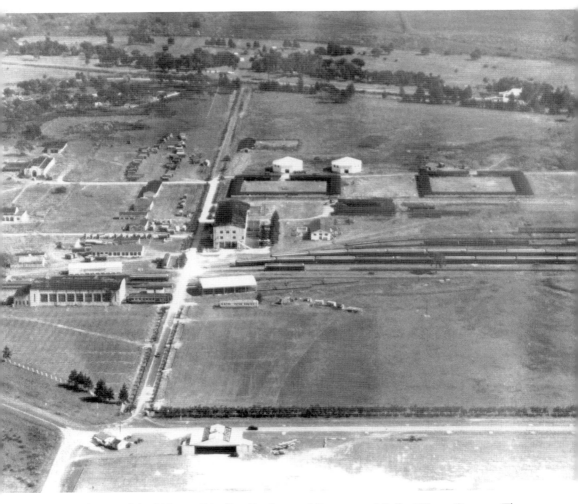

An aerial view of the 200-acre Ringling Brothers and Barnum and Bailey Winter Quarters. The street in the foreground (Oriente Avenue) is today's North Beneva Road. Note the airplanes and the hangar of, believe it or not, Sarasota's airport. The street at bottom left is today's 12th Street. *Sarasota County History Center*

The airport opened on January 12, 1929, and was headline news. According to the *Sarasota Herald*, "the reception of air craft, large or small and the zooming of motors, the swishing of wings and gyrations of planes high in the air will announce to the world that the city has taken its proper place in the category of cities that stand for progress." In 1937 the chamber of commerce convinced National Airlines to make Sarasota one of its stops. But when it rained, the landing strip became too muddy and National temporarily cancelled us out. *Sarasota County History Center*

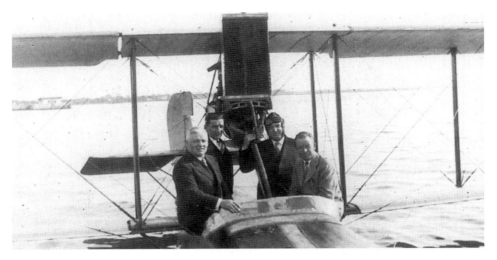

The legendary John J. McGraw about to take off for an air tour of the area. Unfortunately his winning ways on the baseball diamond did not carry over to his local real estate endeavors. The heavily advertised Pennant Park—"One of the Most Beautiful Bits of Homeland in the World"—was a flop, and he and his New York Giants quit Sarasota as a spring training site. During the boom, Captain Rowe, pilot, took lookers aloft in his *Curtiss Seagull*, which was kept in the bay near city pier. Passenger flights were $5.00. *Sarasota County History Center*

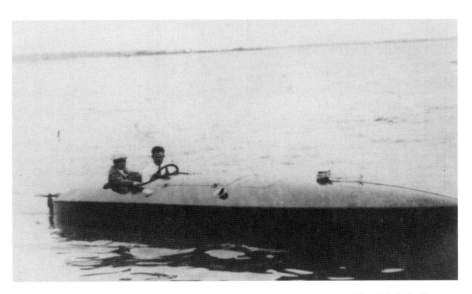

The *Sara-de-Sota* was one of the fastest speedboats afloat according to *This Week In Sarasota*. Brought to Sarasota by Forest Adair Jr., vice president and general manager of Whitfield Estates (left), the boat was capable of sustained speeds of 53 miles per hour. Piloted by Fred Blossom, vice commander of the Sarasota Power Boat Association, the boat was expected to perform well in the senior gold cup races of 1926. *Sarasota County History Center*

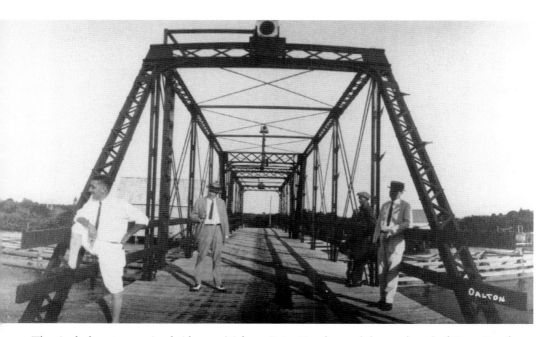

The single-lane truss swing bridge on Stickney Point Road served the south end of Siesta Key from 1926 through the 1950s. A duplicate bridge connecting Casey Key to the mainland at Blackburn Point is still in use today. The bridge was cranked open by hand. *Sarasota County History Center*

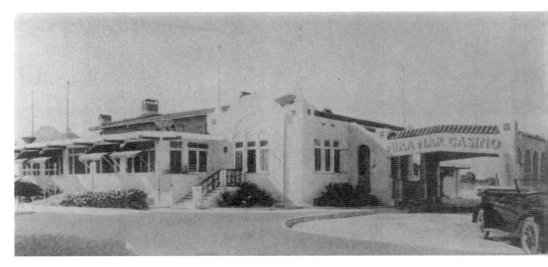

One of the hot spots during the Roaring 20s was the Mira Mar Casino, built by Andrew McAnsh in 1925. It was billed as "Sarasota's Exclusive Night Club." *Sarasota County History Center*

Roberts' Casino was located at the intersection of Beach Road and Ocean Boulevard. It was built in 1920 and acquired by Captain Roberts in 1922. The captain recalled that at the peak of the boom, he could entertain as many as 3,000 guests at one time. The casino offered "all the joys of surf bathing of fresh water bathing in the pool . . . where one may receive the fullest effects of the sun's curative rays." It also had a pier, which extended into the gulf to berth yachts and serve as a promenade for guests. It was destroyed in 1957 to make way for an apartment building. *Sarasota County History Center*

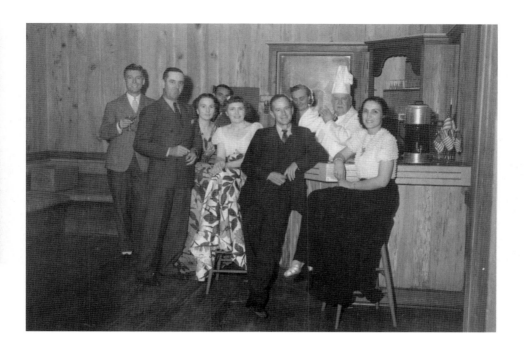

FROM THE REAL ESTATE BUST THROUGH THE GREAT DEPRESSION

Sarasota had a head start on the national misery of the Great Depression. The real estate bust at the end of 1926 saw to that, and by 1928, the town that was electric with the excitement of transforming itself from an out-of-the-way village into a fabulous destination for the rich and famous, came to the realization that the party was over. "Greater Sarasota," which in a rush of optimism had extended its borders to 64 square miles, the size of "a real city," and celebrated the auspicious event with fireworks, entertainment and speeches at city pier, voted to pull back the reins to a "more appropriate" 17 miles in December of 1926.

When the flow of incoming money slowed to a trickle, the droves of "binder-boy" real estate hustlers who had scurried around town generating sales with tantalizing promises of fast profits left as suddenly as they arrived.

Downtown storefronts were abandoned, weeds grew in the streets and housing projects sat wanting. Those who were the last to purchase the binder on a piece of inflated property with the intention of jacking up the price and re-selling were left holding the bag. Perhaps most conspicuous of all, construction on hotels, banks, bridges, fine homes and roads came to a halt.

Building permits, which had soared to over $4.5 million in 1925, fell dramatically to $470,567 in 1927, to $83,596 in 1929 and at the worst of the Depression, to a paltry $51,880 in 1933. Business licenses, which had escalated from 139 in 1923 to 1,057 in 1925, were reduced to 600 by 1931.

The local newspapers—*The Sarasota Times*, the *Sarasota Herald* and *This Week in Sarasota*—which had printed such grandiose descriptions of each fine new building, grand

opening, social event and arival of each important personage were somberly reporting defaults, foreclosures, bankruptcies and receiverships, with *The Times* and *This Week* out of business themselves by 1930. (*The Sarasota Daily Tribune,* which was founded by the Palmer interests in 1934 was absorbed by the *Sarasota Herald* in 1938.)

By the end of 1929, 40 percent of the city's property owners could not pay their taxes and Sarasota's bonded indebtedness, including interest, reached nearly $7,000,000. The reason, editorialized the *Sarasota Herald*, was "taxes and assessments on much of the property upon which there has been default, amounts to more than the property is worth." And this was before the full impact of the Great Depression had taken effect.

Another indication of the city's economic plight was its inability to afford public improvements. The once grand Ringling Bridge—"one of the most important milestones on the march to a new era of prosperity," the *Herald* had intoned—was temporarily closed, awaiting repairs to its rotted wooden planks. On the southern tip of Longboat Key, John Ringling's ultra luxury hotel, the Ritz-Carlton, stood unfinished and was left exposed to the weather—a somber symbol of Sarasota's change of fortune.

Although the halcyon days of the fantastic boom era were obviously over, Sarasota managed its share of bright moments during the late 1920s and the 1930s.

Morale and the economy were given a boost when the March 3, 1927, edition of the *Sarasota Herald* spread the news, "RINGLING CIRCUS TO MOVE HERE." The paper, always exaggerating the obvious, called it "The Most Startling and Important Announcement Ever Made in History of Sarasota." For the next 32 years, Sarasota would be known around the world as the "Circus City." Ten days later, the *Herald* rekindled, albeit briefly, the spirit of the free-wheeling boom era with the headline, "FIRST OIL WELL TO BE STARTED HERE TODAY." Could Sarasota be atop a sea of black gold? Associated Oil and Gas Company representative, Kenneth Hauer, boasted, "should oil be found, and we are certain that it will . . .the first so-called boom will be a gentle zephyr compared to a cyclone." It was much ado about nothing.

In order to perk up the town and the spirits of its citizens, the Founders Circle of the Sarasota Garden Club was formed in 1927 and immediately began to brighten the city with flowers and plants. Other such circles were formed during the Depression years and their work to keep Sarasota beautiful continues to this day.

The Sarasota County Courthouse, built in 1926, was in full use in 1929 and downtown was enhanced by the grand Art Deco S.H. Kress building, which opened in time for Christmas shopping in 1932, and the post office, completed in 1934, with Postmaster General James Farley in town to deliver the keynote speech.

An infusion of Federal WPA money made possible the construction of the Municipal Auditorium, which officially opened in 1938. Construction on the Lido Casino and the Sarasota-Manatee Airport were started that same year. Mayor Smith said that the auditorium was a dream come true and dedicated it for "the pleasure and happiness of winter visitors and residents alike." With its lovely Hazzard water fountain and beautiful Bayfront Park landscaped by the Sarasota Garden Club, the auditorium was the splendid focal point of the 1938 Sara de Sota celebration.

While the years from the real estate bust through the decade of the mostly somber 1930s will be remembered primarily for the national Depression, it was also the era during which the finishing touches were painted on the tapestry of quintessential Sarasota.

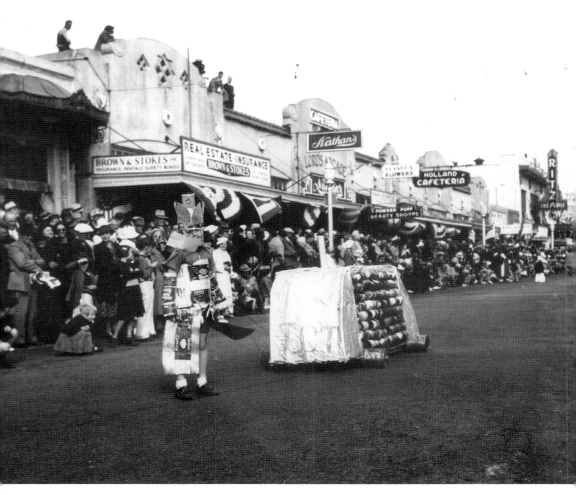

This 1930s photo shows Lord's Arcade next to the Palmer Bank just out of view. The bank and the arcade were built by J.H. Lord in 1925. One of Sarasota's early land barons and boosters, Lord at one time owned the property on four of the five "points" at Five Points. With A.B. Edwards, he convinced Mrs. Potter Palmer to visit Sarasota in 1910 when it was an obscure fishing village. Mrs. Palmer focused national interest on the area by investing heavily here. In the photo, a young man pulls a float representing the Tin Can Tourists of the World. They came to Sarasota by the thousands each year for their annual convention around Payne Park. The object of the organization was "To unite fraternally all auto campers. To provide clean and wholesome entertainment at all campfires. To help enforce the rules governing all campgrounds." The emblem of the order: "A tin can perched on the front of their car." The slogan: "400,000 members by January 1, 1923. No fees. No dues." The Holland Cafeteria, to the right, billed itself as "The Most Sanitary and Unique Eating Place in Florida." *Pete Esthus*

Looking west from the Atlantic Coast Line Railway Station down a quiet, tree-lined Main Street. The Sarasota Terrace Hotel and the courthouse can be seen to the left. Opened for use in September of 1925, the station was a beautiful example of the Spanish Mission look with the waiting rooms decorated "in the same manner as the Mira Mar Hotel, a sky blue color predominating." In 1937, the Sunday *Sarasota Tribune* called the station "A tribute to the certainty of Sarasota's future, and virtually a monument to the foresight of Atlantic Coast line officials." It was demolished in 1987. This is where the Kane Building is today. *Norton's Camera*

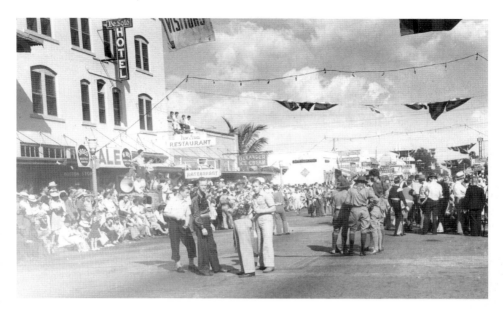

Upper Main Street looking east near Lemon Avenue. A Frog Olympics was added to the Sara de Sota festivities in the late 30s. Hoppers were entered from throughout the state—Stingaree Joe and Sunshine Pete from St. Petersburg, Pensacola in 1940 from Pensacola, Warren for President from St. Augustine—to compete against local favorites Gas House Gertie (alleged sister of 1938 winner Gas House Gus), Old Dan Tucker II and Gator Bait II. To add to the excitement Texas Jim Mitchell did his Hoppi Indian dance amid live rattlesnakes. *Pete Esthus*

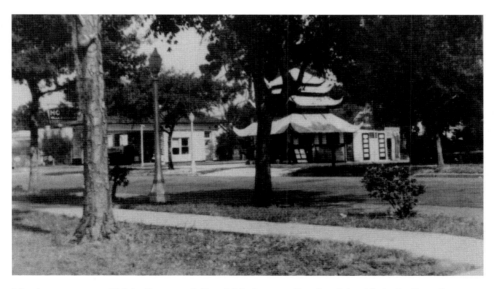

Northeast corner of Main Street and Goodrich Avenue. On the right side is the Pagoda Sandwich Shop. A sign points the way to the Villa Goodrich Hotel. The Pagoda was later moved to Lowe's airstrip at 12th Street and Oriente Avenue (now Beneva Road) across from the circus quarters. Part of the building now stands on Fruitville Road near Myakka. This 1930 photo shows lots of grass and trees downtown. *Sarasota County History Center*

As this 1930s photo of upper Main Street shows, flooding was a yearly problem. During the first five months of 1957, over 35 inches of rain fell. According to *The News*, water and sewers "Top City's Growing Pains." The Independent candidates for the city commission vowed that one of their major goals would be "to get Sarasota out from under water." *Norton's Camera*

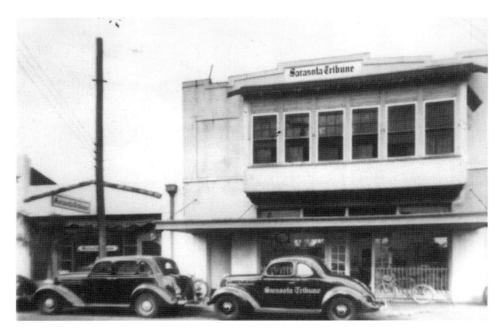

The *Sarasota Tribune* on South Pineapple Avenue was founded by the Palmer interests in 1934 with Benton Powell as publisher. It merged with the *Sarasota Herald* in June of 1938. *Sarasota County History Center*

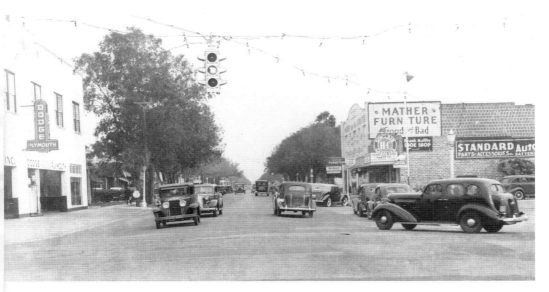

Main Street east of Orange Avenue was renamed Victory Avenue on July 22, 1922, in a ceremony held around the flag pole at Sarasota High School, then located on east Main Street. The street was lined with beautiful oaks planted by Sarasota's Woman's Club and dedicated "to the men of Sarasota County who served their Country in the Great Conflict." Mrs. Frederick H. Guenther, president of the club, intoned that it would be "an avenue of living trees, whose beauty and grateful shade would delight and bless coming generations, long after you had passed on." When the first oak was felled in 1955, *The News* said it went down to "the unfeeling axe of progress." *Norton's Camera*

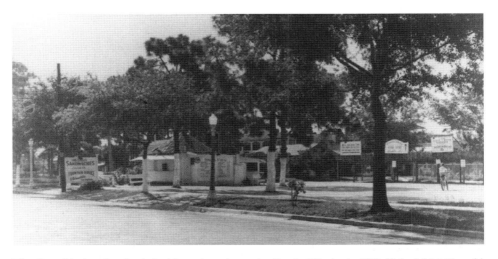

The Smack's shortly after it had been bought as the Ducky Wucky by W.L. "Mack" McDonald in 1934. Mack recalled Sunday afternoons when customers would pull onto the lot to hear Guy Lombardo music piped on a loudspeaker attached to one of the pine trees. In 1938, he moved the business from its original location on Main Street and Pine Avenue to Main Street and Osprey Avenue, where it became one of the most popular spots in town. *Sarasota County History Center*

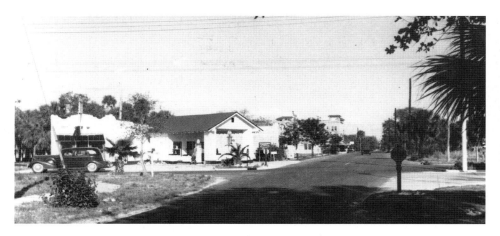

Looking east toward 27th Street from Indian Beach Road at the intersection of highway US 41. The Ringling School of Art and Junior College can be seen in the background. The school building was built in 1926 as the Bay Haven Hotel with "one of the most pretentious and beautiful lobbies in Florida." The hotel went under during the Depression and was bought by John Ringling, who opened it as The School of Fine and Applied Art of The John and Mable Ringling Art Museum in conjunction with Florida Southern College of Lakeland in 1931. The school survived the Depression thanks to a dedicated staff and the "administrative genius" of its president, Verman Kimbrough. Always active in civic affairs, Dr. Kimbrough was elected mayor of Sarasota in 1937 and was one of those responsible for the building of the Lido Casino. Dr. Kimbrough was also the superintendent of the county school system from 1945 to 1953. *Norton's Camera*

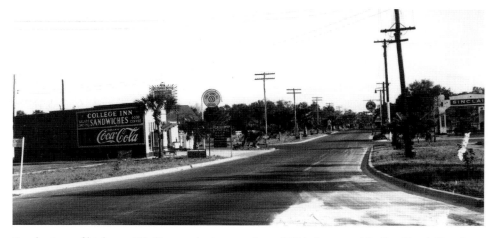

South view of highway US 41 near the intersection of 27th Street and Indian Beach Road in the 1930s. There was much controversy when the highway was ordered to be widened in 1955. The city, county, North Trail Association and the district representative of the state road department protested the 14-foot median strip. Merchants feared that motorists would not be able to cross over to the businesses, which lined the highway. They also disliked the idea that 7 feet of parking would be lost on each side of the street. Their arguments notwithstanding, the engineer indicated that he had "a clear cut mandate that the road would be built with the strip or it won't be built at all." *Norton's Camera*

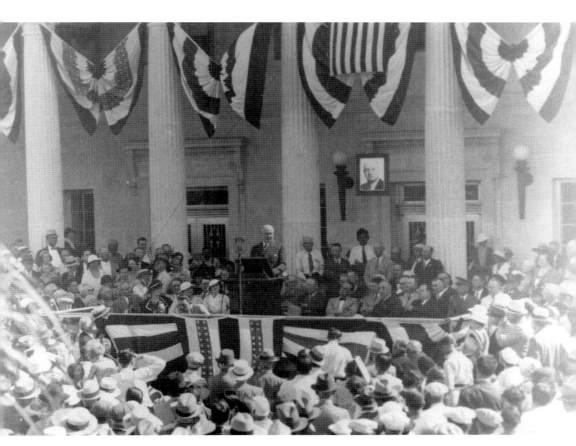

Postmaster General James Farley delivering the keynote speech at the dedication of the post office building on South Orange Avenue, which replaced the old post office site in the Cummer Arcade. Another of the city's WPA projects, the neo-classical building was designed by George Albree Freeman and Harold H. Hall at a cost of $175,000. The building was occupied in November of 1934 and was the last monumental design project of nationally know architect Freeman. *Sarasota County History Center*

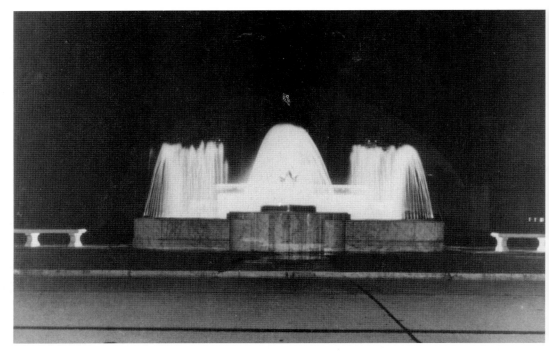

This is the beautiful Hazzard water fountain, donated by shoe manufacturer R.P. Hazzard, which graced the front of the Municipal Auditorium for many years. It was later moved to various sites, most notably the entrance of the Ringling Art Museum. The fountain was designed by Frank Martin whose father, Thomas Reed Martin, designed the Municipal Auditorium, as well as the Chidsey Library and hundreds of beautiful homes throughout Sarasota. In 1991, the city of Sarasota received grant approvals to restore the auditorium and return the fountain, which was in storage, to its original site. *Sarasota County History Center*

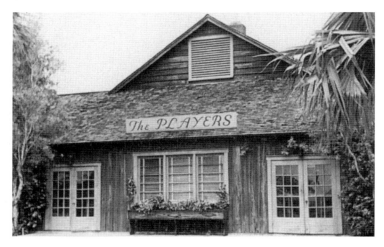

Sarasota's little theater, The Players, was formed in 1929 on Siesta Key and has been a favorite of theatergoers ever since. This building was built in 1936 from a design by Ralph Twitchell. It was torn down to make way for the present, larger theater. *Sarasota County History Center*

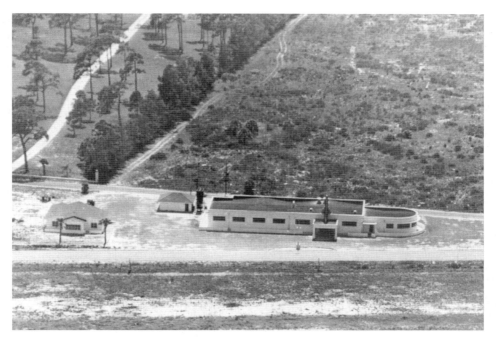

Aerial of the triangle of US 41 and Bayshore Road and Zinn's Restaurant, which opened on this site in 1947 by "Mama" and "Papa" Zinn. This area had previously been a welcoming station for incoming tourists who were introduced to Sarasota with a free glass of fresh orange juice and a cordial welcome. *Pete Esthus*

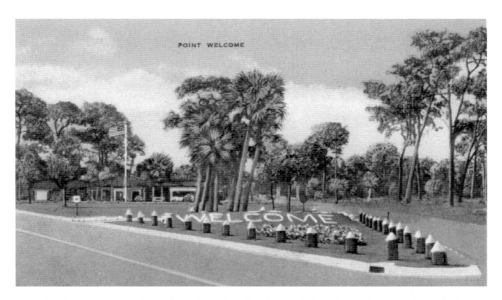

Point Welcome was a project of the American Legion and the City of Sarasota through the chamber of commerce. Jim Drymon, who did volunteer work at Point Welcome, remembered being able to spot tourists from long distances because their cars had a license tag on the front. *Pete Esthus*

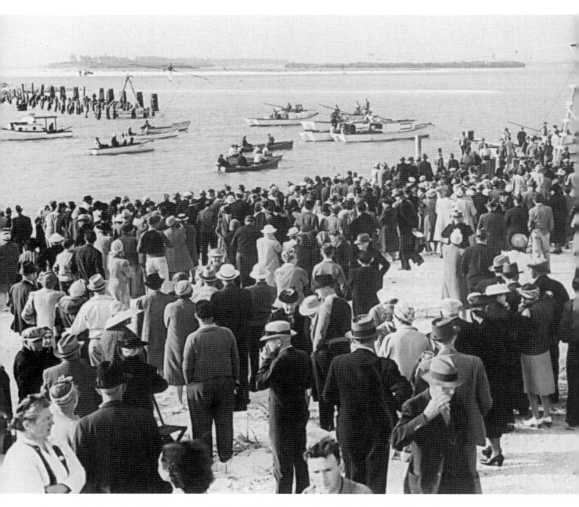

A scam during the 1930s occurred after the bridge to Anna Maria washed out. Someone came to town with the idea of selling stocks to finance a toll bridge. Much interest in the idea was generated and money pledged. This photo shows Karl Wallenda, barely visible on the tight rope, entertaining a crowd of onlookers. *Frank Conrad*

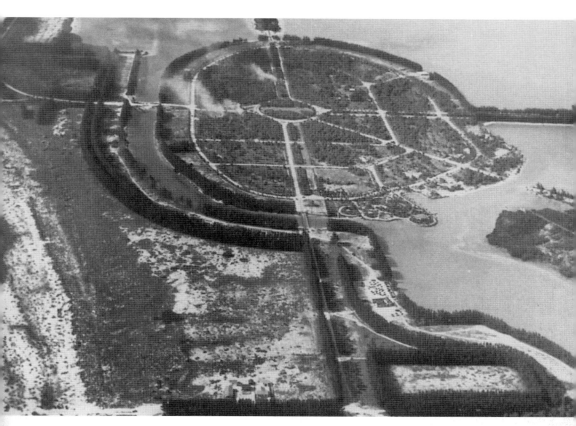

A sparse St. Armands Circle, circa 1937. Named for Charles A. St. Amand, who received a homestead deed for the island in 1893, the island changed hands several times until John Ringling bought it prior to 1920. Plans for his development of St. Armands Key (the "r" was added) were started in 1924 and soon it was called Ringling Isles and then Ringling Estates. The European–like layout was the design of John J. Watson, "one of the most celebrated landscape architects in the country." *This Week In Sarasota* called Watson a genius when the key was opened in 1926. The cars to the right belong to workmen constructing the Lewis Van Wezel home. The road at 4 o'clock, running off of the circle, was intended to connect with Otter Key but was never complete, and today Otter Key is a state preserve. Development around Harding Circle was started in earnest by Colin Brown who built seven stores including the popular Elbow Room and service station in 1950. The first supper club on the circle was The Colony, and the first established business was the G and S Grocery Store. Two of the most popular stores were Sylvia and Steve Lippe's The Basket Bazaar and Jane Hershey's Sea Shanty. *Pete Esthus*

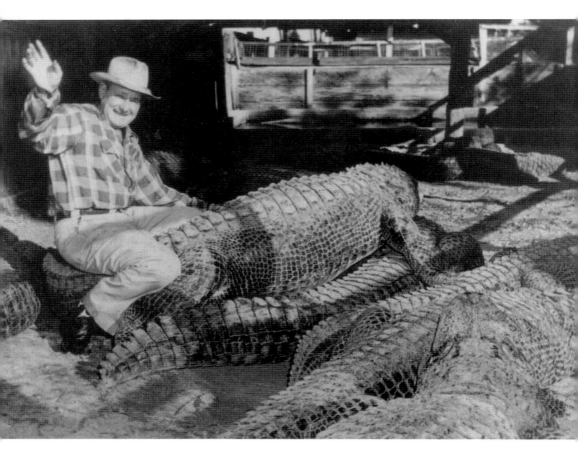

In the alligator pit is Texas Jim Mitchell whose Reptile Farm and Zoo opened in 1935 on Fruitville Road just off Tuttle Avenue Started with $14 in capital, it grew to become one of Sarasota's most popular attractions. Texas Jim was quite a character. In his earlier years, he toured with a medicine show, a Wild West show, and also the theater circuit as a Hopi Indian dancer. One of his friends recalled the excitement he generated when he came into the Oasis Bar on Main Street and emptied a bag of live rattlesnakes on the dance floor. Many remember his rain dances around the war memorial at Five Points. *Pete Esthus*

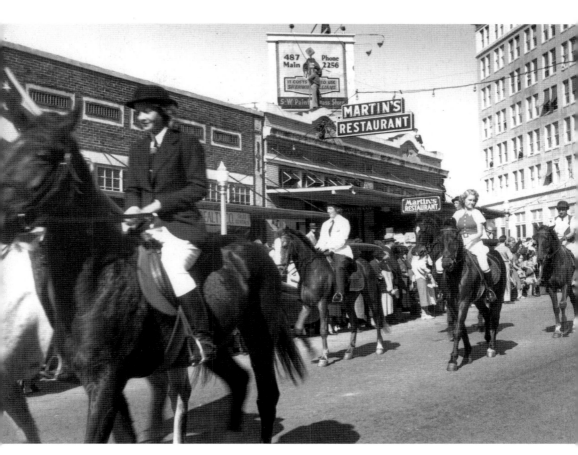

Marjorie Whitaker and other equestriennes in a parade down lower Main Street circa 1930s. *Sarasota County History Center*

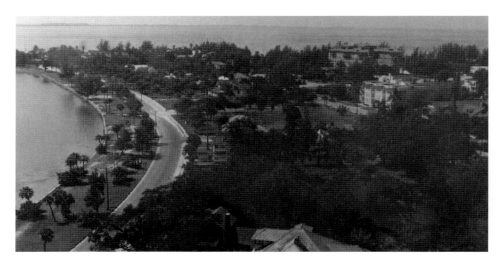

The drive along Gulfstream Avenue was scenic and serene before highway US 41 was rerouted along the bay front. The street curved along the bay front, then through Golden Gate Point on the way to the original Ringling Causeway and the keys. When former city manager Ross Windom returned to Sarasota and saw the new road he commented, "a first class specialist must have designed the drive according to his own wishes, completely mutilating it." In the background are the Frances Carlton Apartments and the Ringling Hotel. Windom was city manager here from 1946 until May 1948. His son, Dr. Robert Windom, is a distinguished physician who served as assistant secretary of health, 1986-1989. *Department of Historical Resources*

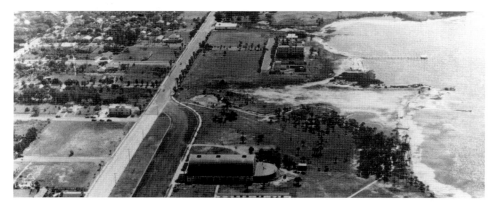

An aerial look south along the Tamiami Trail. The civic center was another WPA project that helped Sarasota make it through the Great Depression. Mayor E.A. Smith called it an important step in the city's development and said it was "a dream come true." On January 9, 1940, the Chidsey Annex to the rear of the auditorium was dedicated. During World War II it served as the army and navy club. John T. Chidsey donated funds for the library building south of the auditorium. For his efforts on behalf of the city, he was named Sarasota's outstanding citizen in 1941. In the late 40s, Karl Bickel sponsored the building of a Spanish replica fort— Fort Juan Ortiz—completed with breastworks, sentry, cannons from various wars, artillery pieces, a French railway car and a tank. Mayor Smith said the complex was "for the pleasure and happiness of winter visitors and residents alike." *Sarasota County History Center*

THE 1940s

At the end of December 1940, the Lido Casino, Sarasota's second major WPA project, was completed and ready to join the Municipal Auditorium as the place to go for a wide variety of social, political and sporting events. It would soon become our beach hallmark; a unique Art Deco fun spot that seemed to personify what life in a tourist haven was all about. Designed by Ralph Twitchell, the *Sarasota Herald* previewed the grand opening of "Florida's Gulf Coast Playground" with front-page coverage, numerous congratulatory advertisements and prophesied that the casino's opening was "An event which will long be remembered in the annals of progress of Sarasota." Nationally known bandleader Rudy Bundy, the man with the "sizzling clarinet," brought his "famous radio orchestra, with Sammy Runyon" to town to open the casino ballroom. Sixteen hundred invitations were sent by the chamber of commerce to notable people throughout the state for a kickoff worthy of what was to become one of the most popular drawing cards in Florida; a place whose demolition at the end of 1969 would signal, for many, the end of yesteryear's Sarasota.

A year after the casino's festive opening, America was embroiled in World War II and thousands of khaki-clad servicemen swelled our population. Within an hour's drive were MacDill airbase in Tampa, Carlstrom in Arcadia and our own army-air force training bases in Sarasota and Venice.

This was the first taste of life in the Sunshine State for most of the servicemen. Their furloughs were spent enjoying the tourist attractions, beaches and particularly the nightclubs along lower Main. At night, the sidewalks and streets were crowded with revelers crossing back and forth between bars, movie houses, restaurants and coffee shops. They flocked to the Tropical Lounge, Cypress Room, Sara Bar, Aztec and D.C.'s Manhattan, which changed from "The Place Where Friends Meet" to "Where Fun Begins" and offered at "THE BAR OF DEFENSE," cocktails with names like F.D.R., TAPS, AIR RAID and BLITZKRIEG. (When D.C. Ashton was called up, he ran this ad: "Good-bye boys! Let's Buck the Japs! I am off for Camp Blanding. Like you, I will try to do my part. In the meantime, have a swell time.")

The servicemen were the largest group to come to Sarasota since the Tin Can Tourists' yearly migration, and local businesses catered to them with "special rates to army personnel" and "discounts to men in uniform." The base newspaper, Rex Kerr's *Air Field Eagle*, "First in the Field with the News," kept the boys tuned into where to go and what to do in town. "Dance at the Army and Navy Club. Charming hostesses on hand to eliminate all wall flowers." The Novelty Gift Shop advertised, "Ship back home, as a souvenir of your stay in Florida, LIVE BABY ALLIGATORS and TURTLES." The Bowladrome offered "Schlitz

Draft Beer, 10 oz.–10¢."

Buses shuttled from the base to downtown and those who missed the last run could find a free bed at the American Legion Coliseum.

Many of the trainees fell in love with this tropical paradise, its fantastic sunsets, beautiful weather and friendly natives, and vowed to return.

For the locals, the war was rationing, victory gardens, censored mail on tissue-thin paper, limited travel (an A coupon book was good for only four gallons of gas per week) and buying war bonds: "They give their life, you lend your money." To many it meant teary-eyed farewells, daily prayers and a long, long wait.

When it was finally over, the American Legion War Memorial in the center of Five Points would be inscribed with the names of the 67 Sarasotans killed in battle, a poignant reminder of those who would never return.

Postwar Sarasota was on the threshold of another era of prosperity and to prevent the mistakes of the chaotic boom-time 20s, a newly elected city commission hired Colonel Ross Windom to be the first city manager. It was his job to chart a proper course when the lifting of wartime restraints allowed Sarasota to go forward again.

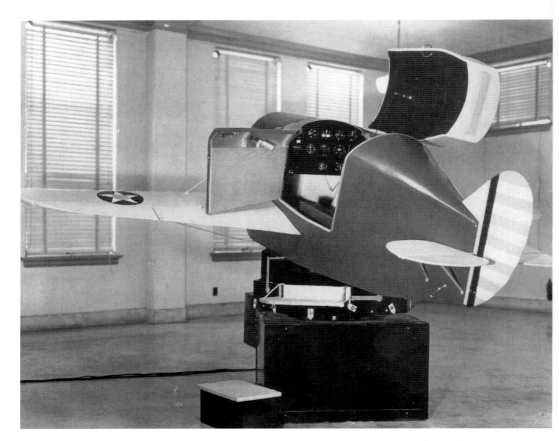

Training at the Sarasota-Bradenton Army Air Base included time in this Link flight simulator. *Sarasota County History Center*

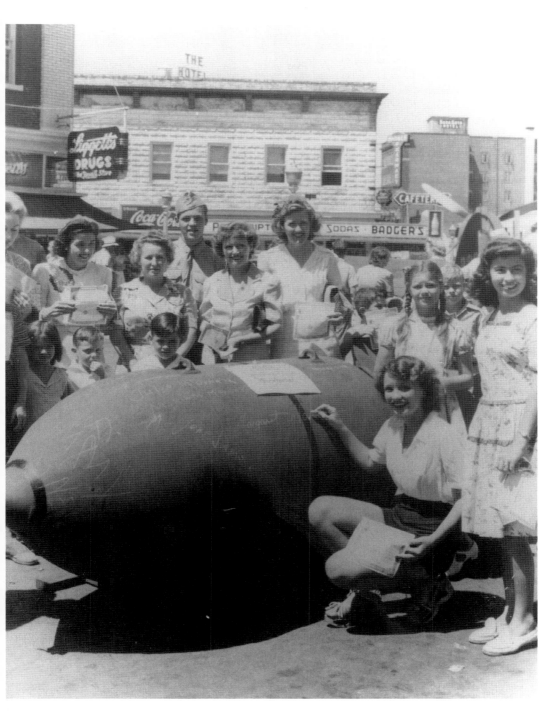

Bond drives were an important part of the war effort on the home front. Pictured here, a "blockbuster" bomb being autographed for delivery to the Axis. In the background, the propeller belongs to a P-40 Warhawk fighter plane. This photo was taken at Five Points on July 8, 1943.
Pete Esthus

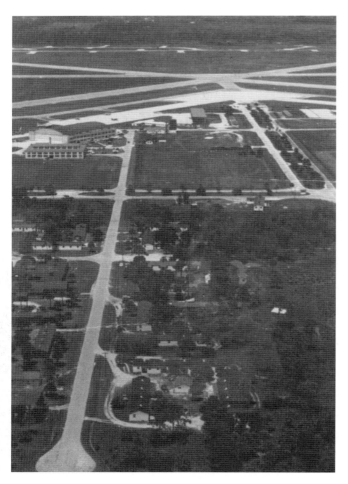

Looking north at Sarasota's modern airfield. Work on this field was started in 1938 as another WPA project. During the war, it was used as a bomber training base and a year later was used as a fighter training base. *Sarasota County History Center*

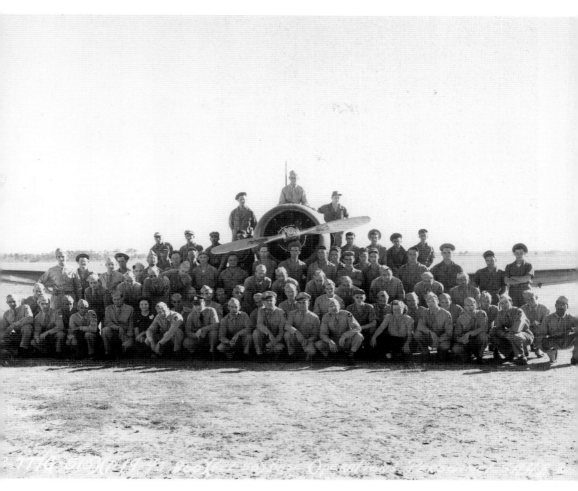

Some of the nearly 3,000 army–air force trainees that the base could accommodate. *Sarasota County History Center*

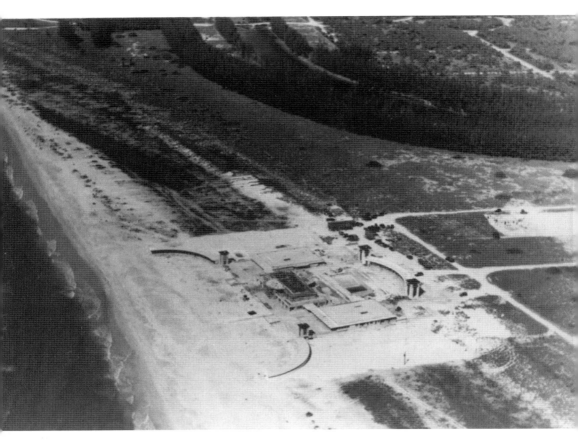

Construction was nearly complete on Sarasota's fabulous Lido Casino when this picture was taken. Designed by Ralph Twitchell, this WPA project was one of the most popular attractions in the city's history. Rudy Bundy, the man with "the sizzling clarinet," and his orchestra came to town for the grand opening—and stayed. *Pete Esthus*

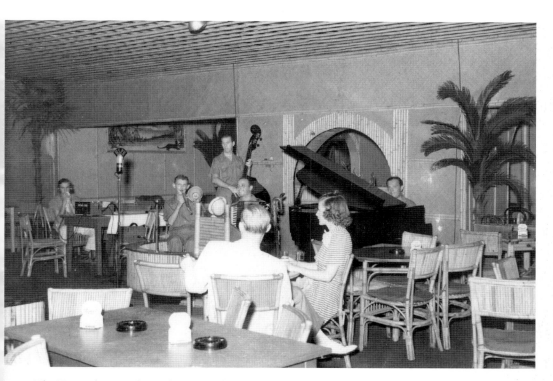

The Tropical, a popular nightspot, on lower Main Street was one of the main "watering holes" for servicemen during WWII. Pictured here, a couple listens to a remote broadcast by WSPB. *Joan Griffith*

Pictured hereis one of the circus acts that performed in the John Ringling Hotel. It was John Ringling North who imbued the hotel with the trappings of the circus, complete with a brass-buttoned giant for a doorman, Captain Heyer and his beautiful horse, Starless Night, high-wire performers and other Big Top acts. *Joan Griffith*

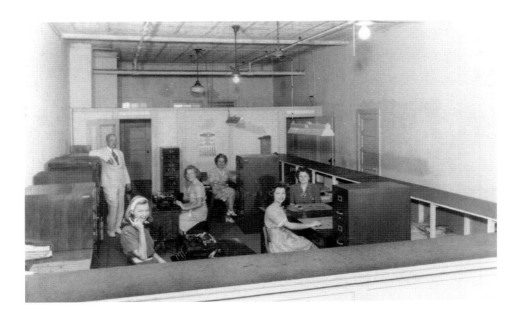

Staff of the War Price and Ration Board: W.E. Smith, brother of Mayor E.A. Smith, Mildred Williamson, Marjorie Esthus, Maisie Bayless, Sara Martha Cheney and Loretta Tabor. Smith served throughout the war for no compensation. When he resigned in December of 1945, Smith said, "There have been many headaches to this job and in a few instances we have incurred the ill-feeling of thoughtless citizens. On the whole, however, I found the people of Sarasota County very co-operative in assisting us." *Pete Esthus*

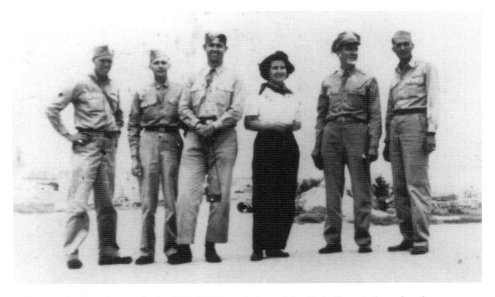

Sarasotans far from home during WWII. From left to right: Dale Brye (whose brother, Gordon, later owned The Tackle Box on Main Street), Allen Hardison, Edwin Burns, Lillian Burns (whose father, Owen Burns, was responsible for much of Sarasota's early development), George Anderson and an unidentified man. *Lillian Burns*

How far can a Willys go without adding oil or water? Captain John Holliday got this one to go 4,419 miles averaging 30.9 miles per gallon. This picture taken in March of 1937 shows an exhausted-looking captain at the Amoco Service Station near Five Points. In 1940 Sarasotans were treated to a more spectacular exercise in automotive derring-do when Indy winner, Wilbur Shaw, demonstrated his driving skills under hazardous circumstances. In an exhibition sponsored by Firestone, dynamite was used to blow out a Life Protector tire at a high speed and Wilbur managed to bring the car to a stop under perfect control. The point of the exercise was clear to those who drove with dynamite strapped to their tires. *Sarasota County History Center*

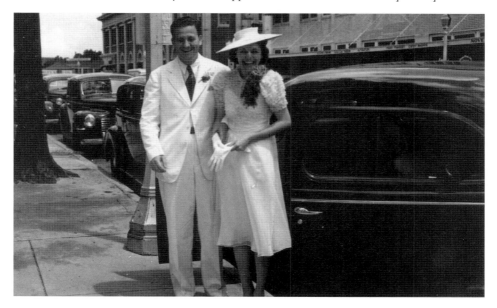

Happy newlyweds, W.T. Robarts and his beautiful bride, Bonnie Ellis, pictured after their marriage in 1940. The building to the right is the Halton Hospital. *Pete Esthus*

Sarasota's youngest sheriff, 29-year-old B. Douglas Pearson, was appointed to complete the term of his father. He was then elected three times, serving from 1939 to 1953. His father, Clem Pearson, was sheriff of Sarasota from 1933 to 1939. Here, Sheriff Pearson is outfitted to lead the Sara de Sota parade. *Deputy Sergeant. Bob Snell*

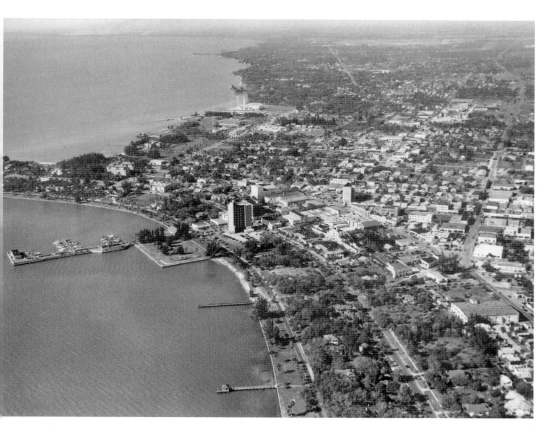

Looking north along Gulfstream Avenue—city pier juts into the bay at left, circa the late 1940s.
Joe Kent

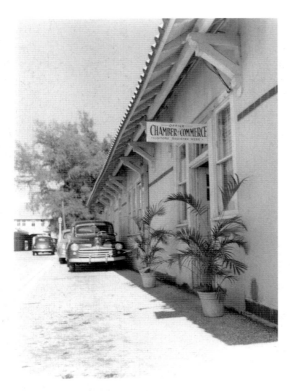

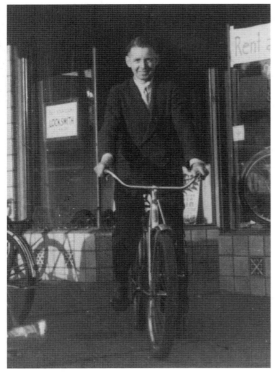

Top: One of the driving forces behind Sarasota's growth and development has been the Sarasota Chamber of Commerce, pictured here when it was located at city pier. In 1957, it moved to the Japanese-style offices south of the civic center. This building was burned by the fire department in a controlled fire in 1958. In the booming 20s, the chamber's first building was on State Street where a live alligator served as mascot. *Sarasota County History Center*

Bottom: If you bought a bicycle in Sarasota in the 30s, 40s or 50s, you probably purchased it from Arthur Esthus, who was the first Schwinn dealer in town. He started out on Main Street with a typewriter and key shop, moved to Central Avenue in 1931, where he stayed until 1951, when he moved to State Street where the business was run by his son, Pete, as the Sarasota Lock and Key Shop until 2004 when Pete retired. This picture was taken about 1936 and shows the elder Mr. Esthus on one of his Schwinns in front of the shop on Central Avenue. Mr. Esthus was elected city commissioner in 1945. *Pete Esthus*

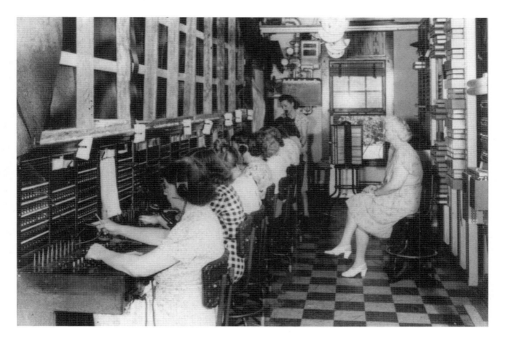

Operators of the Peninsula Telephone Co. being supervised—in the real sense of the word. This picture was taken when the company was located on Mira Mar Court behind the Cummer Arcade. In 1947, Sarasota had 5,505 phones. A new numbering system was introduced in 1956 with four exchanges: Ringling, Elgin, Fulton and Export. By 1957, Peninsula had 23,000 subscribers here and 2,750 in Venice. *Sarasota County History Center*

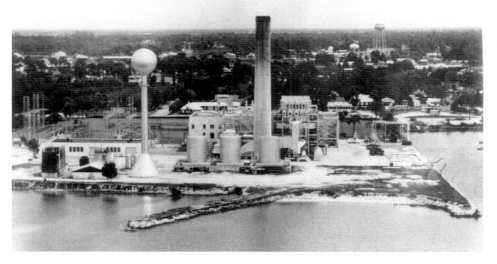

A welcome addition to the west coast was the new Florida Power and Light plant on Payne Terminal. Built for a reported $1,500,000, the project was started in 1945. The area had previously been dependent on power transmitted from the east coast supplemented by small local plants. Today, this is the site of Centennial Park.

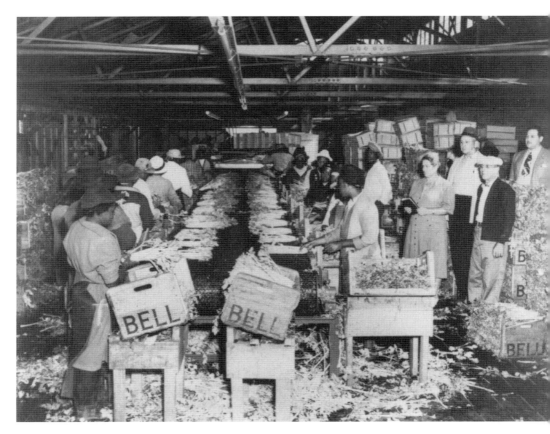

Agriculture was once the mainstay of Sarasota's industries. Here, in their packing plant, are Tom Bell and his brother, John, overseeing their workers. *Tom Bell*

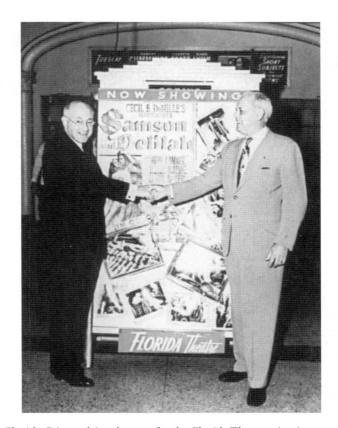

Harry Vincent, manager of the Florida, Ritz and Art theaters for the Florida Theater circuit from 1945 to 1957. Here, he shakes hands with Cecil B. DeMille who was in town to promote *Samson and Delilah*. *Joan Dunklin*

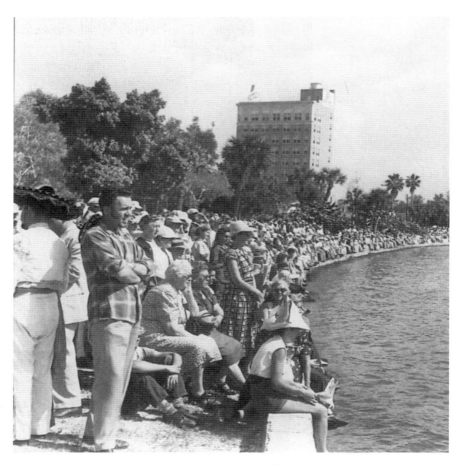

Lined up along the bay front to watch one of the sailing events for the Sara de Sota Pageant. *Sarasota County History Center*

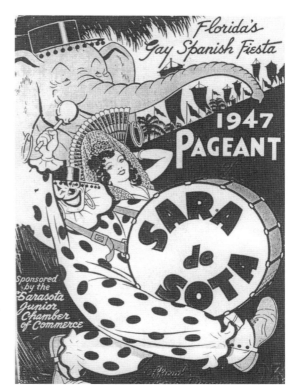

Right: Pictured here is the cover of the program for the 1947 Sara de Sota pageant. *Sarasota County History Center*

Below: An inviting window display of the wines and cordials available at Baccus Liquors.

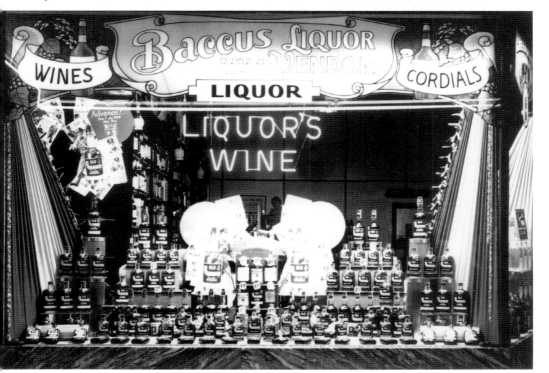

How to Live on..
$15.00 A WEEK
— IN SARASOTA

BACCUS Liquor Store	$8.80
Wifes Beer	1.65
Meat, Fish, Groceries	On Credit
Bus Fare	1.50
Rent	Pay Next Week
Life Insurance (Wifes)	.50
Dog Bets	Borrow From Friends
Cigars, Cigarettes	1.20
Taxi Fare	Use Thumb
Bridge and Poker	1.90
Punch Boards	.50
Clothes	See Mama and Papa
Laundry	.60
TOTAL	$16.65

This runs you into debt — so cut out wife's beer

BACCUS

255 MAIN STREET PHONE 2353

Baccus Liquors on lower Main Street offered advice on how to make ends meet on $15.00 a week in Sarasota.

FOR "UNUSUAL" BOYS
BAILEY HALL

This school, with summer headquarters in Katonah, New York, offers **over-active, slow** or **retarded** boys an adjusted program of physical and mental training. Effective methods, specially designed educational aids, sympathetic care. Special department for younger children. Attractive location on private beach.

RUDOLPH S. FRIED, Principal
SARASOTA, FLORIDA

One of Sarasota's more progressive private schools, Bailey Hall, circa the mid-1940s.

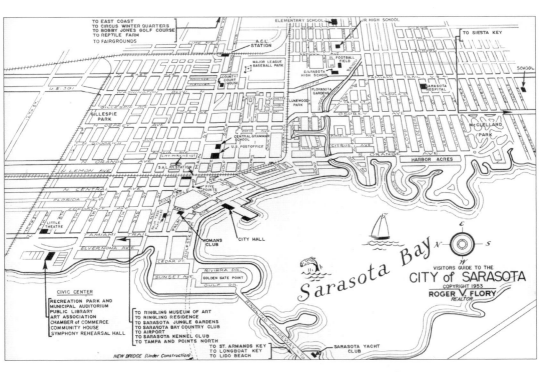

What to do and see in Sarasota circa the 1940s. *Sarasota County History Center*

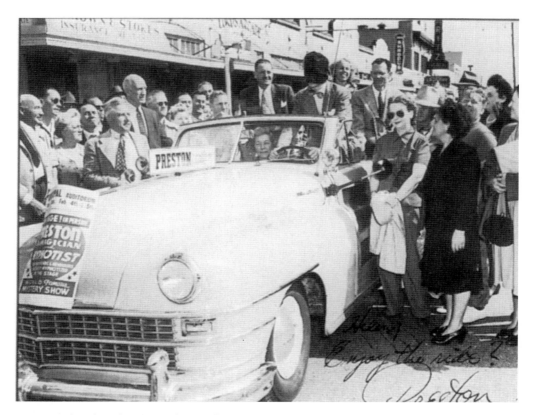

For more than four decades, Helen Griffith kept Sarasotans apprised of the comings and goings of our rich and famous visitors. Over the years she interviewed everyone from mathematical genius Albert Einstein, to "Blond Bombshell" Betty Hutton. Here, Helen gets a ride with Preston the Magician who was in town for a 1949 performance at the Municipal Auditorium. *Joan Griffith*

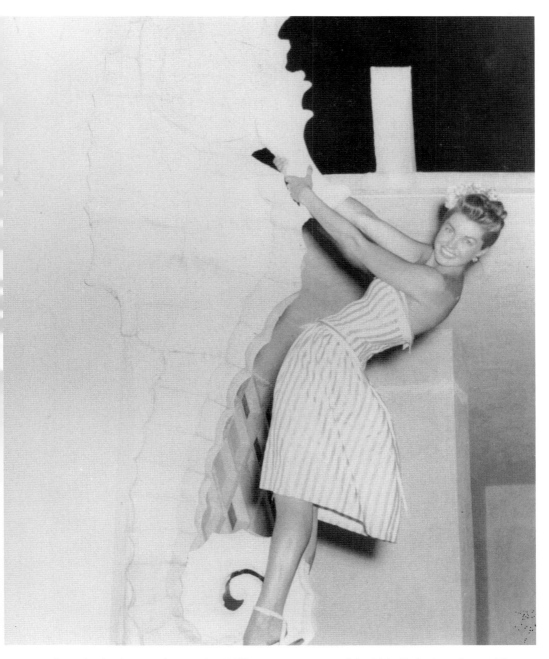

Looking absolutely marvelous, Esther Williams poses on one of the Lido Casino's sea horses. The Hollywood mermaid was in town a few days in June of 1947 to do some on-location filming for the MGM production *On An Island With You*, which co-starred Peter Lawford, Ricardo Montalban, Cyd Charisse and Marie Windsor. Scenes were shot on Lido Beach, the Sarasota-Bradenton Airport and the Anna Maria Island Airstrip. Most of the cast and crew stayed at the Orange Blossom Hotel. The underwater scenes were filmed at Cypress Gardens and the jungle scenes on Biscayne Key. *Pete Esthus*

Mayor E.A. Smith presents to renowned violinist Rubinoff the key to Sarasota in this 1941 photo. Mayor Smith was a driving force in the development of Sarasota particularly during the WPA days of the Great Depression and also during WW II. He was elected mayor in 1933, 1935, 1939, 1941 and 1945. He was also instrumental in developing Harbor Acres. *Department of Historical Resources*

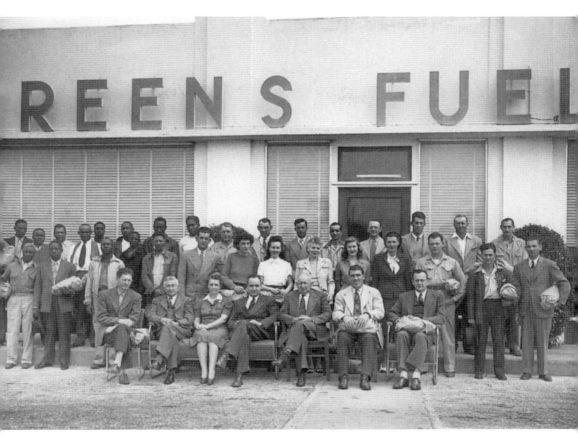

Invented and developed by J.B. Green and his son, Taylor Green, Green's Fuel System utilized previously wasted hydro-carbon gases which were liquefied under pressure and burned hotter than natural gas. Green's Fuel grew from humble beginnings in the 1920s to become internationally renowned. In 1940, a Green's Fuel System was installed at President Roosevelt's estate at Hyde Park. J.B. Green died in 1953. Pictured here, Christmas turkeys under their arms, are the staff members. Seated from left to right: Taylor Green, J.B. Green, Sarah Jackman, Kenneth Koach, Harry Price, George Higgins (who would become famous for his volunteer efforts for numerous causes in Sarasota) and Walton Taylor. *Susan Granger*

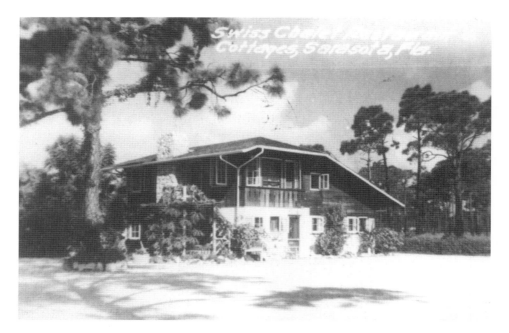

The Swiss Chalet at the intersection of what is today Siesta Drive and highway US 41 served "Food Fit For Angels." *Sarasota County History Center*

Tuttle Avenue near Greenbriar Estates, mid-1950s. *Pete Esthus*

THE 1950s

For the first time since the short-lived boom years of the 1920s, Sarasota was awash with optimism. The city government was finally out of the red financially and the local newspapers were once again touting our obvious resurgence: "City Building Hits $9,625,981 . . . 545 houses put up in one year," "1950 . . . a milestone in Sarasota's progress," "1956 population up 52% since 1950" and "Summer Tourist Boom burgeoning Around Town."

So it went throughout the decade. Increases were being made in every facet of our growth and reported like box scores. The number of tourist rooms nearly tripled between 1946 and 1956, restaurants doubled and offered three times the seating capacity, and in 1955, telephones increased to 18,087. Trailers soared from fewer than a hundred after World War II to over 3,000 by 1954.

The following full-page ads showcased new housing developments: "Paver Park, $2,500 down—$55 per month," "Nature Was Smiling When She Made Sarasota Springs," "Melody Heights—Where Your Life Will Always Be A Song," South Gate was transformed from an orange grove in to "Where You Live Among The Orange Blossoms" and "Greenbriar, Sarasota's First Moderately Priced Split Level House, $13,750." The list seemed endless— Kensington Park, Lake Sarasota, Desoto Lakes, Leisure Lakes, Brentwood, Oak Shores, Phillippi Gardens, Bayshore Gardens and others.

Comparisons to the freewheeling 20s were made. But there was a major difference. As *The News* put it, "Everything indicates that real estate in Florida is no longer a speculative venture. There is slim chance that the current boom will collapse into another sensational bust." Prominent real estate agent Roger Flory, who was active during both eras, recalled for

The News, "Fortune hunters [of the 1920s] came from all parts of the country to buy acreage for subdivision purposes. They gave no thought to drainage, utilities, or other improvements. They laid out four lots to the acre and would sell each of these lots for a price originally paid for the acre, and they left the city holding the bag as far as any improvements were concerned. " In the 50s, people bought property to build homes on, not to resell for a quick profit as in the 20s.

"Modern" and "progress" were the often repeated catchwords of the day and along with giant full-page advertisements offering affordable housing were announcements for groundbreakings, dedications and grand openings of restaurants, hotels, motels and shopping centers. (South Gate was billed as "a glittering emporium of merchandising; a new era in West Coast shopping.") The *Sarasota Herald Tribune* reported, "Construction signals Sarasota's expansion. A gradual change is taking place in the face of the city as . . . new buildings rise day by day." The chamber of commerce formed the Committee of 100 at the end of 1955 to attract light industry and within a year, EMR announced they were coming to town with a reported payroll of 800 and $4 million for the economy. The chamber also campaigned to lure summer visitors. The two major detriments to year around tourism were said to be mosquitoes and lack of waterfront property. But heat must have been another factor, for the chamber angrily blasted a magazine article that mentioned a temperature of 105°. "Florida boosters have spent millions to break down the popular fallacy that it is hot in the summer." *Sarasota Visitors Guide*, published annually by Roger Flory since the late 20s, increased its mailing to 37,500 in 1955, and the popular mail-away editions of the *Sarasota Herald* and *The News* showcased Sarasota in its entire tropical splendor. In September of 1956, *The News* bragged, "No summer slowdown in busy new Sarasota. Unlike former years, business booms during hottest months."

Growth and progress had their price. Downtown homes that had added to the charm of the city were moved to make way for new construction. In 1954, one of our most visible landmarks, the war memorial in the center of Five Points was suddenly deemed a traffic hazard and was moved to Gulfstream Avenue. After the Mira Mar Auditorium was demolished, *The News* noted, "it had bowed to progress," and a week later reported, "First Memorial Oaks Topples To Progress." An editorial called their removal, "The Bitter Fruits of Progress." A group of concerned citizens formed Friends of Friendly Oaks (FOFO) and fought the good fight to protect these living tributes to our World War I doughboys. The oaks had lined Main Street from Orange Avenue east to the Atlantic Coastline railway station since 1919, but the city commissioners believed they stood in the way of downtown development. One commissioner said we could have the oaks or progress—not both.

Another radical change occurred when the beautiful drive along Gulfstream Avenue was altered to accommodate highway US 41. This too was met with opposition and prominent homeowners took their case for riparian rights to court.

Lido Key author, Mrs. Mary Freeman, wrote an article for *The Nation* entitled "American Myth—You Can't Stop Progress." She warned that Sarasota might turn into "an imitation Miami populated by pasty, paunched men with big cigars." *The News* quoted her as saying, "We can still take things in hand . . . but the citizens must make a more intelligent and louder noise than the speculator. Otherwise he'll destroy our unique assets . . . in an effort to reproduce Miami."

But despite the on-going transformation, we had more ties to our past than we were to have with the future. For most of the decade, we still crossed over to Lido Key on the original Ringling Causeway, took out-of-town friends to the circus winter quarters, cruised Smack's, dined at the Plaza, had fountain cokes at Badger's, were governed from city hall on lower Main Street, walked long stretches of the pristine beaches and greeted visiting friends at one of the two railway stations or the bus depot, all on Main Street.

The Sarasota of the "nifty fifties" maintained the ambiance of a small, friendly town. Memories reflect not to the construction and development but to local happenings: Cecil B. DeMille's arrival to film *The Greatest Show On Earth* with Hollywood's most popular stars; the two visits of our namesake ship, the attack transport USS *Sarasota*; dancing at the M'Toto Room or the Casa Marina Lounge to the "sizzling clarinet"; turning out by the thousands for the Sara de Sota pageant with its elaborate and colorful closing parade; rooting for the Sarasota Sailors football team to beat their arch enemies, the Manatee Hurricanes; bumping into one of our famous writers, artists, sports figures or circus personalities; being kept up to date on social events by Helen Griffith, our Main Street Reporter; greeting the circus train when it pulled into town.

Finally, and most important, we had a sense of being members of a unique community—we were still Sarasotans.

The Sarasota Welfare Home on Orange Avenue is today The Pines of Sarasota. *The Pines of Sarasota*

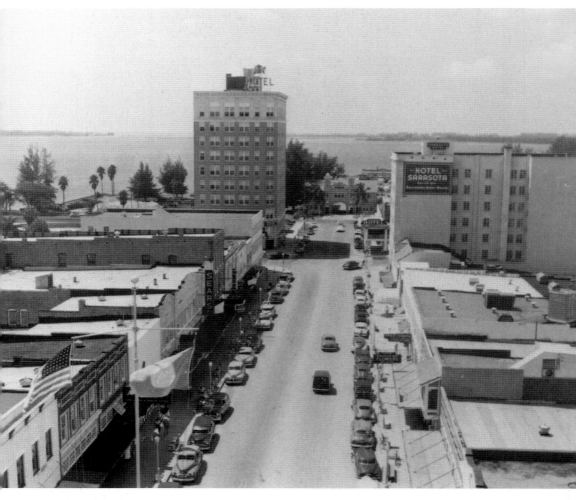

By the 1950s and even into the early 1960s, lower Main Street remained as it had been since the boom-time 20s. The red bricks of the Hotel Sara Sota had been painted white and several businesses had remodeled their storefronts, but there were more similarities than differences in this popular section of downtown. By the end of the 1960s, however, the buildings on the south side (left) of the street to the Orange Blossom Hotel were demolished to make room for a parking lot; the Hover Arcade was leveled to make way for a few benches and a water fountain. Note the United Nations flag flying from the war memorial flagpole at Five Points. When the flag was first raised, Sarasotans were told that we had "the distinction of becoming the first city in the nation to signify its allegiance to the high aims of world peace and friendship." The UN flag, however, caused a flap among the Disabled American Veterans who wanted it removed because the Soviet Union, a UN member, was supplying arms to our enemy. The flag remained. *Sarasota County History Center by Joseph Steinmetz*

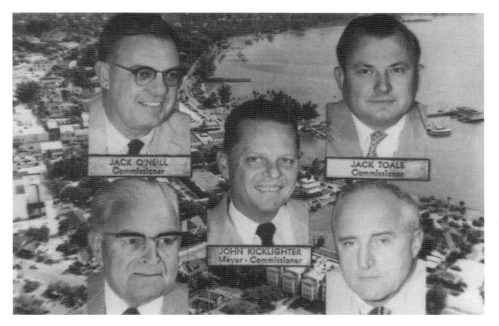

The city commissioners of Sarasota circa the mid–50s when the city's business was still being conducted at the old Hover Arcade. *Sarasota County History Center by Joseph Steinmetz*

The old Hover Arcade. *Sarasota County History Center by Joseph Steinmetz*

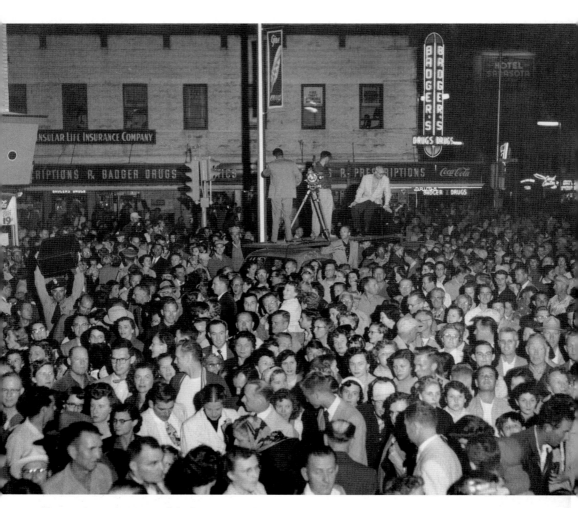

Above and opposite: One of the big events of 1954 and another modern milestone for Sarasota was the change over to fluorescent lights downtown. On October 26, the anniversary of Edison's discovery of the incandescent light bulb, the old streetlights were turned off by Sarasota's First Citizen, A.B. Edwards. After a brief black-out, the five year-old-son of Mayor Ben Hopkins, Ben Hopkins Jr., threw the switch for the new system, "illuminating Main Street in all its fluorescent glory." As these three photos show, there was a lot of celebrating going on. *Department of Historical Resources*

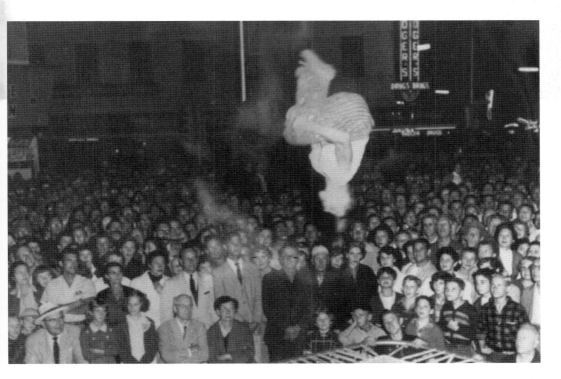

Looking south from Five Points on Pineapple Avenue in the early 1950s. Madison's Drug Store opened here in 1951 in what had been Liggett's Drugs. This "flat iron" building was built for the Bank of Sarasota in the 'teens. On the right is the rear of Badger's Drugs, the Cummer Arcade, which housed the post office and Florida Power and Light Company office, and the First Methodist Church. *Sarasota County History Center by Joseph Steinmetz*

Looking from the Palmer Bank building at Five Points along North Pineapple Avenue. To the left is Montgomery-Roberts, which moved to this site from Main Street in 1946, having purchased the building for $75,000. This site had formerly housed the Fenne-Howard Motor Company. After extensive remodeling, Montgomery-Roberts would become one of our most fashionable department stores. It boasted the city's first escalator. Adjoining it to the left is Morrison's Cafeteria, today's Golden Apple Dinner Theater, and to the right is the Florida Theater, refurbished today as the Sarasota Opera House. The John Ringling Hotel (formerly the El Vernona Hotel) is in the background. *Sarasota County History Center by Joe Steinmetz*

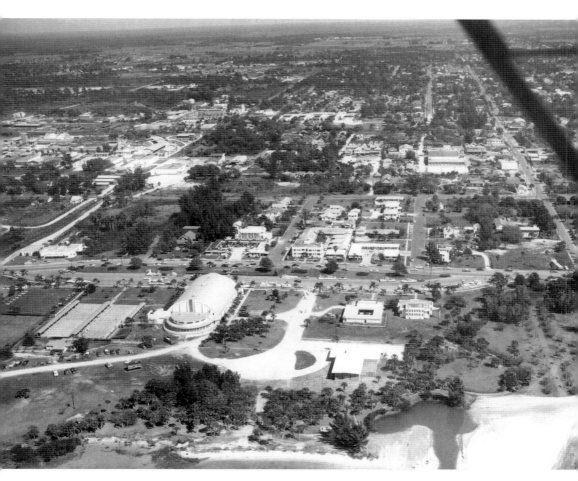

Above: Looking east at the Municipal Auditorium and environs in the mid–1950s. Across the Tamiami Trail from the left are Green's Fuel, the Players, Bickford, Hilltop, Lalinda and Clearview Motels. To the far right are two rows of trees on Honor Parkway, which were planted by the Founders Circle of the Sarasota Garden Club to honor the Sarasota men and women who served in WWII. *Sarasota County History Center*

Right: Here, a 1953 proposal for the modern replacement of the John Ringling Causeway and with it a proposed causeway extending from 12th Street to City Island. *Sarasota County History Center by Lionel Murphy*

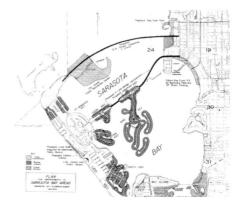

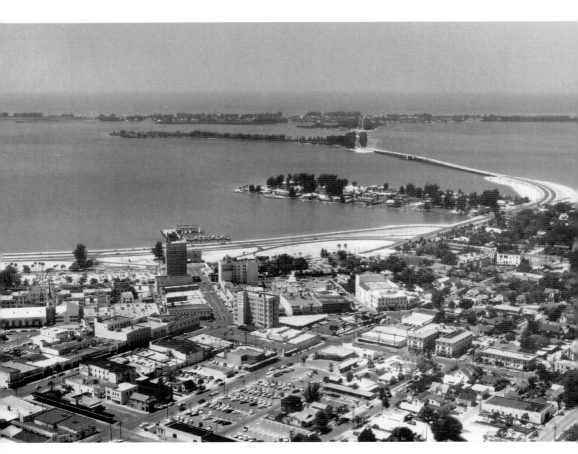

Construction underway on the new causeway, sans many of the original proposals. It was initially offered as a $7 million package, which called for a toll, a bridge link to Siesta Key from Lido Key, and a highway along the Bayfront. *Sarasota County History Center by Lionel Murphy*

The Sarasota Diner was originally a 42-foot Pullman car that was brought to Sarasota in 1944 by J.J. Howley and G.W. Helms and set up on the southeast corner of Main Street and Orange Avenue behind the Sinclair gas station. The diner offered short-order meals as well as full dinners and was open 24 hours a day. *Sarasota Visitors Guide*

The northeast corner of Main Street and Orange Avenue in 1954. The bus station opened here in July of 1943 as the "most modern of all of Florida." The terminal was said to be able to handle as many passengers as the Union Bus Terminal in Jacksonville. This site had been the location of Jungemyer Motors and on January 1, 1956, would become the home of the Sarasota Bank and Trust Company. Today, it is the Bank of America. *Pete Esthus*

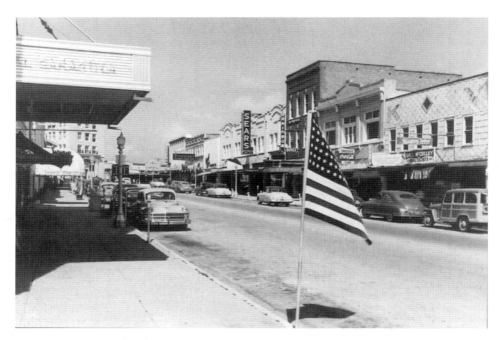

Lower Main Street. *Photo by Joe Steinmetz*

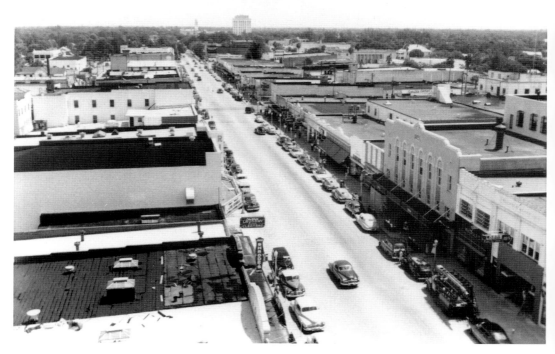

Upper Main Street. *Photo by Joe Steinmetz*

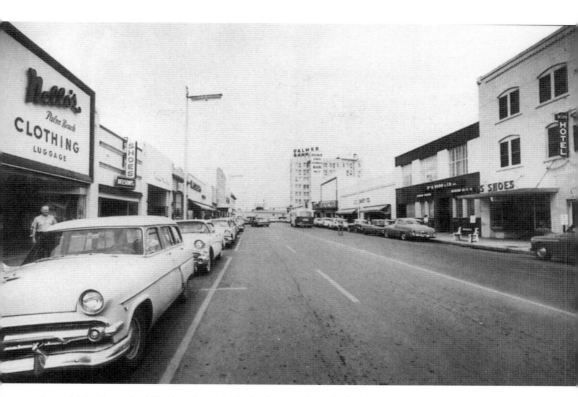

Upper Main Street in 1959. To the right is the Desoto Hotel (the third time a hotel bearing that name had been located on Main Street). The William H. Wood Company building had been the site of the Ringling Bank and later the Sarasota Bank and Trust Company. Beyond Penney's is the Ritz Theater with its new façade. *Anne Marconi*

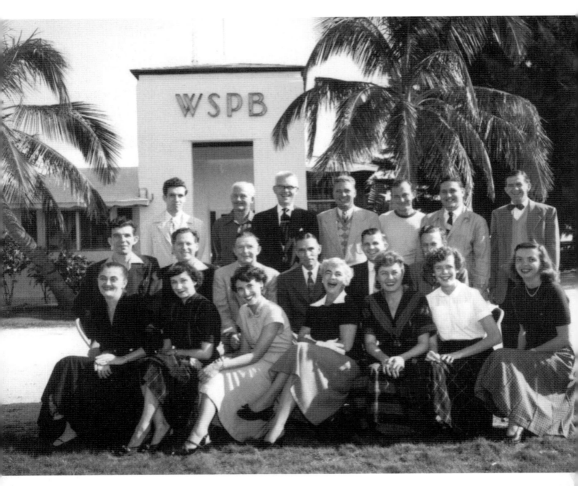

WSPB went on the air on December 7, 1939, from their station on City Island. The station had been offered its choice of two sites and chose City Island because the surrounding saltwater acted as a conductor of electrical impulses. The land was purchased for a nominal fee and was to revert back to the city if the station was not maintained for 15 years. It was one of the first stations on the Florida's coast to broadcast news each hour and consequently drew many listeners from Tampa and St. Petersburg. After five "lean" years, the station joined CBS. Pictured here is the staff circa 1953. Front row, left to right: JoAnne King, Marie Richardson, Jay Belle, Petey Swalm, Dottie Mead, Eleanor Brown and Ruth E. Hearn. Second row, left to right: Al Marlow, J. "Mac" Miller, Mr. B., Mr. Jones, Dean Fleischman and David Hale. Third row, left to right: Don Priest, Bandal Linn, Hack Swain, Herb Splander, Jimmy Grant, Paul Roberts and Woody Thayer. *John Browning*

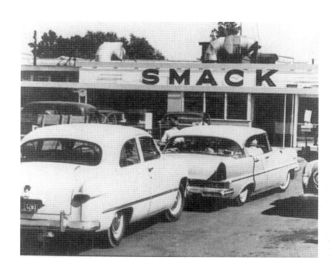

Into the 50s, Smack's was still the favorite place to cruise and to meet.
Sarasota County History Center

After Smack's closed, McDonald's was the place for the younger set to meet. According to *The News*, Sarasota was the first city in the state to have a "Golden Arches" when it opened in April of 1957.
Sarasota County History Center

Sal Cuomo is credited with bringing pizza to Sarasota. He was dubbed the "Pizza King" and had several popular restaurants, this, his last, midway between Sarasota and Bradenton near the airport. *Sarasota County History Center*

By 1959, the Sara de Sota Pageant had been renamed "Sarasota Pageant" and a Scottish theme replaced the Spanish "legend" of Sara Sota and her Indian prince, Chi Chi Okobee. Here are Royal Court members Dave Chambers and Anita C. Kane.

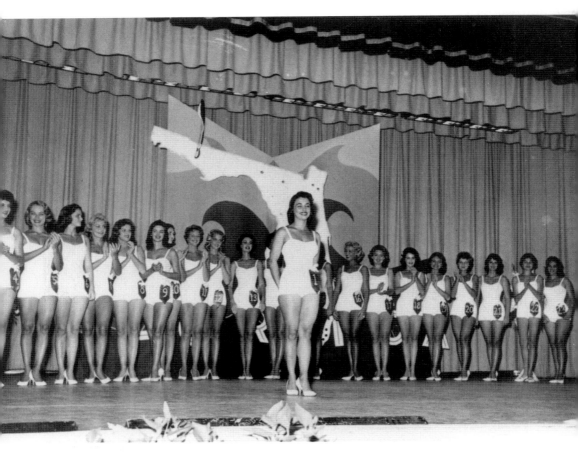

The Miss Florida pageant was first held on the west coast in Sarasota in 1956 with Miss Sharon Walker representing Sarasota. Here, a beautiful and radiant Manuela Cash, Miss Sarasota for 1959, poses for the judges. Her brother, Joe Cash, was world water skiing champion in 1957. *Mrs. J.C. Cash*

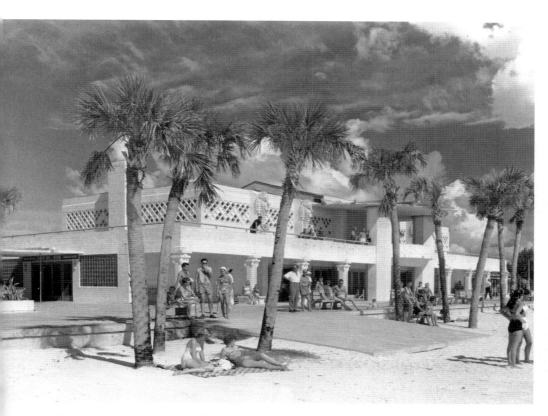

The fabulous Lido Casino, one of Sarasota's all-time fun spots.

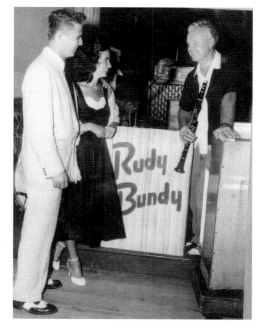

One of Sarasota's most popular entertainers, Rudy
Bundy, the man with the "sizzling clarinet," came
to Sarasota to open the Lido Casino. His theme
song, "Thrill," thrilled dancers and listeners at
the Casa Marina Lounge, the M'Toto Room and
numerous other clubs.

Each year Monsignor Elslander, pastor of St. Martha's Church, with his altar boys blessed the circus trains before they departed for the yearly tour. It took 90 of the silver cars to carry the circus to 150 towns around the country. The first section of trains carried the personnel, tents, cookhouse, equipment, blacksmith department, animal cages, trucks, stake driving machines, floats, ticket wagons and side show tent and equipment. The second section carried the various big top tents, pole wagons, stake wagons, diesel lighting plants, seat wagons, concession wagons and personnel related to the above. The final section was made up of Pullman sleeping cars carrying the performers, executives and office personnel. *Captain Max Frimberger*

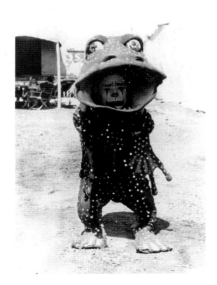

The Big Top was folded for the last time in Pittsburg in July of 1956. John Ringling North announced the tented circus was dead. This little man looks like he just got bad news. *Captain Max Frimberger*

The Doll family: Grace, Harry, Daisy and Tiny with friend, Ted the Giant. *Joan Griffith*

Sarasota's Little League program was started in the summer of 1948 with eight teams in Sarasota and two in Venice. Games were played at Payne Park until 1954, when they were moved to the diamond on 12th Street. Pictured here, the fearsome Citizens Bank team. Little League was founded in 1946 by Carl Stotz who said, "The only true measure of success in Little League is the degree of benefit derived by the boys." Many local boys remember Bill Howard, who was named Sarasota's Citizen of the Year in 1957 for his contribution to the youth of Sarasota. *Sarasota County History Center*

Payne Park was named for Calvin W. Payne who deeded the land to Sarasota in 1925, although the city started using the park in 1923. Sarasota's first major league spring training team was Mighty John J. McGraw's New York Giants, who came here in February 1924. Word that the Giants were coming was good news to the small community, which stood to reap a harvest of nationwide publicity from the sports writers who would follow the team and send stories to all the large newspapers in the country. The Giants stayed for 3 seasons and were followed by the Red Sox who stayed for 25, and then the White Sox began training here in 1960. *Sarasota County History Center*

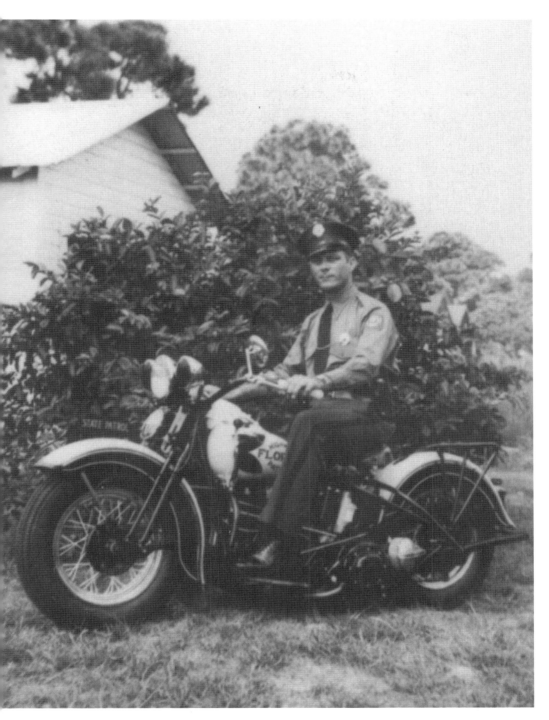

Florida highway patrolman and soon-to-be elected sheriff of Sarasota County, Ross Boyer. In 1954 Sheriff Boyer employed a staff of thirteen deputies, two school officers and two office workers. His area covered 55 square miles and 42,000 people. *Sergeant Bob Snell*

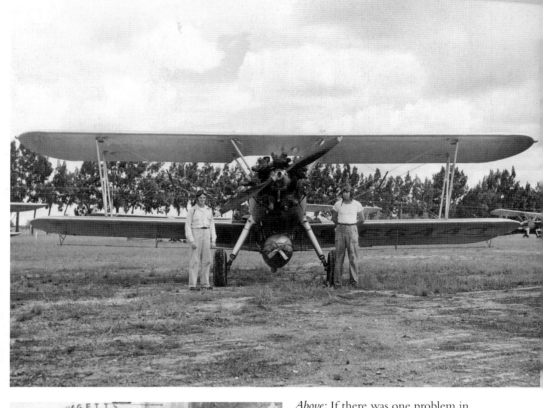

Above: If there was one problem in paradise it was those darn mosquitoes. Mel Williams helped bring the problem under control with the help of this biplane and fogger jeeps. *Sarasota County History Center*

Left: The "Thrill of Victory" being pushed by "The Agony of Defeat" down upper Main Street. Don Self, president of Sarasota Rotary, pays off a bet to competing service club President Milton Hess of the Kiwanis in September of 1954.

St. Martha's School was established by Monsignor Elslander in 1950 with an enrollment of 174 students. Teachers were sisters from the Order of St. Benedict as well as lay teachers. *Sam Montgomery*

Sarasota Bank and Trust when it was located on upper Main Street, west of Lemon Avenue. Known as "The Friendly Bank," it moved in 1956 to Main Street and Orange Avenue. *Sarasota County History Center*

First Federal Savings and Loan was organized in 1934 by William Guy Shepard who was its first president. Under the leadership of Shepard and later George K. Page, it became one of the largest financial institutions in the country. *Sarasota County History Center*

T.J. Bell's Citizens Bank, across the street from the post office was the first in the east to offer drive-up service, which Mr. Bell had investigated while on a trip to Los Angeles. *Sarasota County History Center*

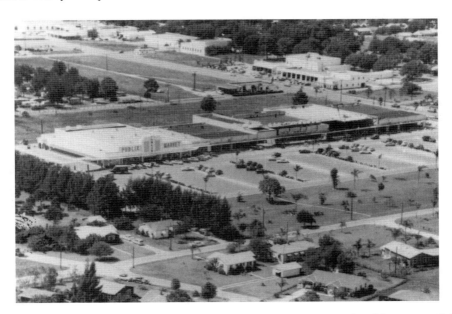

Ringling Shopping Center was Sarasota's first major shopping area outside of downtown. Publix Supermarket opened for business in April of 1955 on the site of Bert Montressor's Driving Range. Publix was convinced to come here by local resident Jean McKelvey, who wrote them that Sarasota would make a great location. Miss McKelvey was introduced at the grand opening as "the young lady responsible for bringing Publix to Sarasota." The first stores in the center were: Beauteria, Belk-Lindsay, Butterfield Toy Shop, Center Shoe Repair, Crews Barber Shop, Crowder Bros. Hardware, Darby Cleaners, Diane Shops, Grant Sweet Shop, Publix, S&H Stamp Redemption Center, Touchton Drugs and F.W. Woolworth. In the background are Sunshine Buick (later Darby) and Johnny's Auto Wash, "Your Car Washed in 8 Minutes." *Pete Esthus*

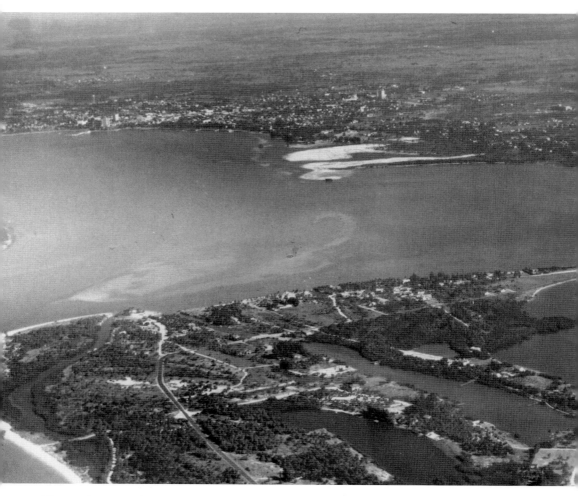

The northern tip of Siesta Key in the foreground with a recently dredged Harbor Acres at the upper middle of the photo. An article in the March 25, 1951 *Sarasota Herald Tribune* said, "The growth of Harbor Acres from an uninhabited jungle tract to a $3,000,000 development paced the growth of Sarasota in the post war years." *Pete Esthus*

Members of the Sarasota Police Force, circa 1950. Front row: Francis Scott, Fred Walker, John Ward, William Berry, Walter Polukewich and Walter Whitted. Second row: William Hooper, Robert Rushing, Tom Hubbell, Jack Lehrer and Arthur Johnson. Third row: Charles Legg, R. Edward Royal, Irving Nelson, August Wrashe. Top row: Garrett Kierce, Luther LeGette, Earl Parker and John C. Wingate. *Luther Legette*

This "air miles to" sign stood on the corner of Washington Boulevard and Ringling Boulevard in front of the Sarasota Terrace Hotel. *Captain Max Frimberger*

In 1953 there were 66 members of the Sarasota County Bar Association. Today this group numbers more than 650. *Mary Cutler, Sarasota Law Library*

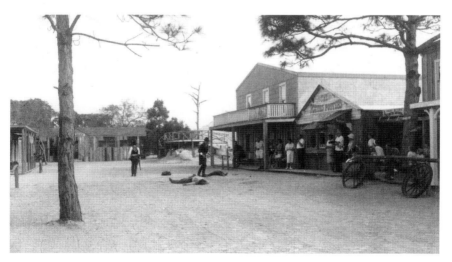

Street scene from Floridaland, Philip C. Smashey's tourist attraction, which offered "Everything Under the Sun." By the 1950s, Sarasota offered the following attractions: The Sarasota Jungle Gardens, Texas Jim Mitchell's Reptile Farm, The Circus Winter Quarters, Horn's Cars of Yesterday, Sunshine Springs and Gardens, The Circus Hall of Fame, the Ringling Art Museum, the Museum of the Circus and Ca' d'Zan. *Sarasota County History Center*

Hap's Cycle Sales started as a branch of the Harley Davidson repair shop in St. Petersburg in 1948. Hap was an employee at that time and was transferred to Sarasota to manage the store. In 1949 the shop was granted a Harley Davidson franchise and in 1950 moved to what is now 4th Street where it remained until 1963 when it moved to its present location on 17th Street. *Hap Poneleit*

Upper Main Street. The William H. Wood Co. offered the four-way test for customer satisfaction. "Is it the truth? Is it fair to all? Will it build goodwill, better friendship? Will it benefit all concerned?" This had previously been the site of the Ringling Bank and the Sarasota Bank and Trust, which opened here on December 4, 1939. Here, Ricky Meyers helps a youngster in the children's parade. *Sarasota County History Center*

The All American Soap Box Derby racing program was founded by Dayton newspaperman, Myron E. Scott, in 1934 and has been run each year since, except during WWII. The local 1956 event was won by Jeff Jernigan who then got to compete in the nationals in Akron, Ohio. *Sarasota History Center*

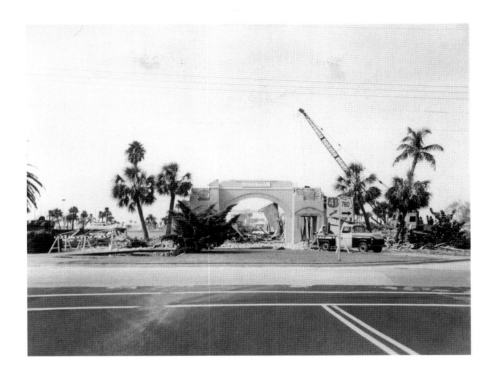

THE 1960s

The curtain to yesteryear's Sarasota did not ring down overnight, and then rise the following day to showcase its modern replacement. We entered the 60s a relatively small and tranquil community, and while we still had much in common with our past, the future was rapidly approaching.

One of the tragedies of modern Sarasota is that so much of its past has been unnecessarily sacrificed. One of the most obvious examples of this is the city hall building, seen above, demolished in the late 1960s. We were no longer the "Circus City." Highway US 41 was routed alongside Gulfstream Avenue destroying what had been a picturesque drive along the water's edge, effectively isolating the downtown area. But even then we could look to the west and see the Hover Arcade intact. Why should it not be? It had graced the foot of lower Main Street since 1913.

If we were going to Lido Beach we crossed over the bay on the new version of the Ringling Causeway and passed Bird Key, Arvida's first major development. But when we arrived, the Lido Casino was there to enjoy. Siesta and Longboat Keys retained the atmosphere of tropical islands—but not for too much longer.

Downtown, the memorial oaks were nearly all gone, the American Legion war memorial had been removed from the center of Five Points and businesses were obviously feeling the ever-increasing spread outward, but one could take in a movie at the Ritz, have a cup of coffee or a cherry Coke at Badger's, shop at Montgomery-Roberts, lunch at Morrison's or the Plaza and buy practically anything, from groceries to automobiles, near the heart of the city.

The Mira Mar Auditorium had been demolished, but our major hotels—John Ringling, Orange Blossom, Sarasota Hotel, Sarasota Terrace and Mira Mar Hotel and Apartments—were catering to our out-of-towners.

The building that housed the boom-time weekly, *This Week in Sarasota* and later the Casa Madrid Restaurant and Lounge, had its tower lopped off but was still being used by the VFW. Further south on Pineapple Avenue, the U.S. Garage was operating as Anderson Ford, small businesses occupied the Cummer Arcade, and across the street, the Halton Hospital building was still standing. Much of the Mediterranean look that gave Sarasota its distinctive charm was rapidly giving way to generic, modern aluminum facades. In 1965, many of the buildings on the south side of lower Main Street, including Badger's Drugs and the Downey Building were demolished to make room for a parking lot. The old city hall (Hover Arcade) with its drive-through archway that led to city pier would soon follow.

A photograph in the March 29, 1969 *Sarasota Herald-Tribune* showed a man standing under a Royal Palm tree next to a pile of twisted metal and chunks of concrete. It was the rubble of the Lido Casino. "Festivities will return soon," the caption said, "because plans are on the drawing board to build another expanded casino in the same location."

Fifty years had elapsed since the revelers had gaily danced beneath "the bright moon's rays" at the Golf Holding Company's New Year's Eve party. They had heeded the *Sarasota Times'* call to "dream big dreams, and then work to make (your) dreams come true." The early boosters and developers transformed an unheard of, out-of-the-way jewel of a village called Sarasota into an idyllic resort. Their dreams and hard work had, indeed, come true.

Perhaps the *Sarasota Herald-Tribune* photo of the destruction on the fabulous Casino signaled the end of their era—the future had arrived.

Looking west along Ringling Boulevard. *Sarasota County History Center*

Intersection of highway US 41 and Bee Ridge Road. When this section of the South Trail was being widened, Dixie Lee Eggers, owner of Dixie Lee's bar, "The Poor Man's Stork Club," gave his address as "Boondoggle Boulevard" and said his bar was recommended by Duckin Hide. Across the street, Al Abdulla's Flamingo Bar had outside seating. Today this is the site of Einstein's Bagels—only in America, folks. *Sarasota County History Center*

Bahia Vista Street just east of the Phillipi Creek Bridge and into the peaceful Mennonite Village of Pinecraft. Yoder's Grocery Store and the Eatin' House were favorite gathering places. *Pete Esthus*

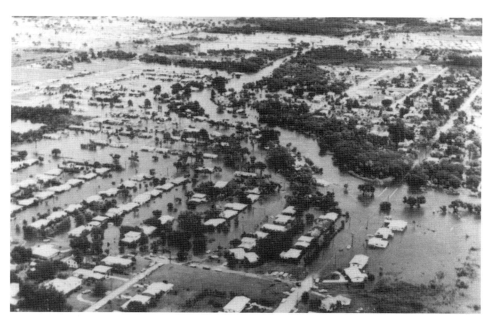

"The creek's a risin'." This is the aftermath of a rainstorm in 1962 that was dubbed the worst in 100 years. Phillipi Creek overflowed its banks and flooded a vast area. This picture shows Bellevue Terrace, Oak Shores and Pinecraft. The street at the right is Bahia Vista where it crossed Phillipi Creek. *Sarasota County History Center*

Ed Marable operated a grocery store in the Osprey Avenue area after he bought the business of F.H. Slee in 1940. The market grew to become Sarasota's largest independent grocery store. Marable was elected to the city commission in 1956 and was mayor in 1961. In 1969 Marable's was bought by Ted Morton who had managed the store for many years. Today, as Morton's, the store is operated by Ted's son, Ed Morton, and offers the same fine service for which Marables had always been known. *Sarasota County History Department*

Lobby of the Florida Theater, circa 1950s. The neon sign advertises Carlyn Seiters, a woman's wear shop across the street. *Joan Dunklin*

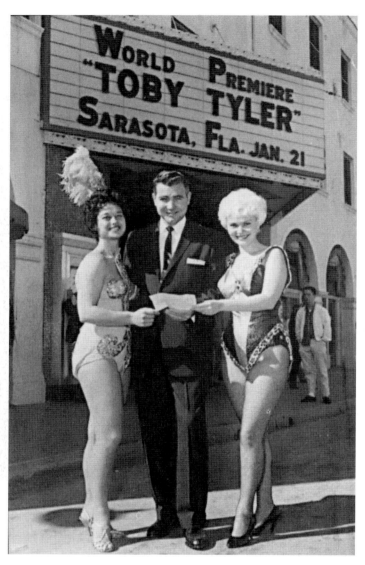

Most know that the world premier of *The Greatest Show On Earth* was held at the Florida Theater. A less heralded premier was *Toby Tyler* on January 1, 1960. Pictured are Jan Christiani (left) and Vicki Christiani of the Christiani Brothers Circus. Another circus movie, which drew a lot of local attention, was *Trapeze* with our own Willy Krause and Sally Marlow doing the aerial work. *Sarasota County History Center*

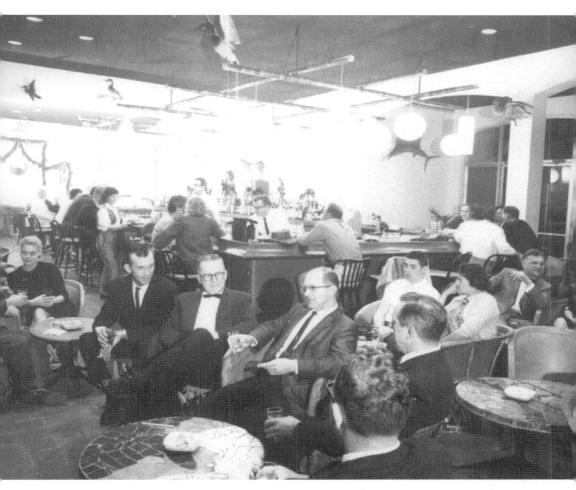

One of the most popular night clubs in Sarasota was the Explorers on St. Armands Circle.
Sarasota County History Center

Ground breaking ceremony for the construction of Cardinal Mooney High School in April of 1960. Monsignor Elslander Pastor of St. Martha's, and Friar Joseph Daley, president of the school and pastor of Incarnation Church, dig in while Dr. Droege and Father McCall look on. In the background are Mrs. Gerow and Mrs. Flynn who helped raise funds for the project.

The most popular of all Sarasota restaurants, The Plaza on First Street, noted for its excellent cuisine, attentive staff, and charming atmosphere. Partners Benny Alvarez, C.G. "Raymond" Fernandez and Randy Hagerman turned the restaurant into a local landmark that continued to draw customers for over thirty-five years. *Sarasota County History Center*

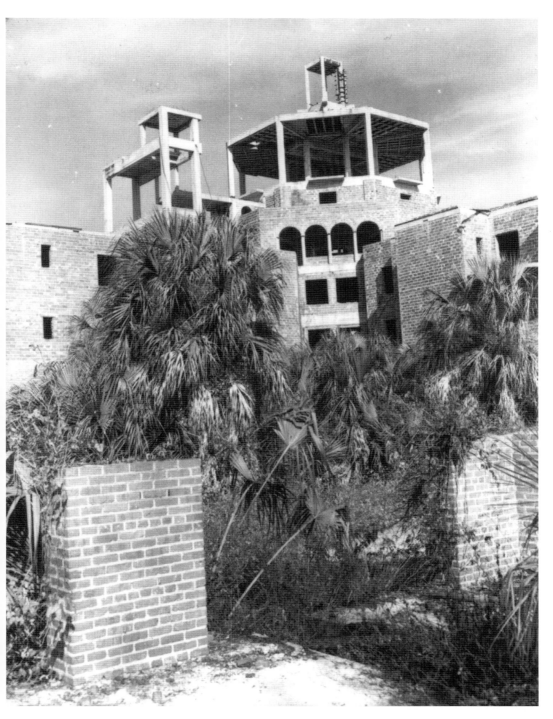

Forlorn reminder of a boom-time dream that would not come true, John Ringling's Ritz-Carlton Hotel on the southern tip of Longboat Key. This Steinmetz photo was taken just before the building was demolished in 1964. *Sarasota County History Center*

As president and chairman of the board of Palmer Bank, Benton Powell played an active part in the growth of the community. He was named president of the bank in 1933 and guided it through the Great Depression to become one of the most respected financial institutions in the country. Powell also published the *Sarasota Tribune* from 1934 to 1938 when it was bought out by the *Sarasota Herald*. He was on the boards of numerous organizations and was one of those instrumental in bringing New College to Sarasota. *Mrs. Benton Powell*

Sarasota has been fortunate to have so many teachers and counselors who have been willing to go the extra mile for their students. Ed Swope was among the best of this group of unselfish educators. When Riverview High was established, Mr. Swope transferred over from Sarasota High. When he died in 1974, Ross Smith wrote of him in a poem, "He gave so freely of his life; Without a thought of personal strife." *Candy Miller Guess*

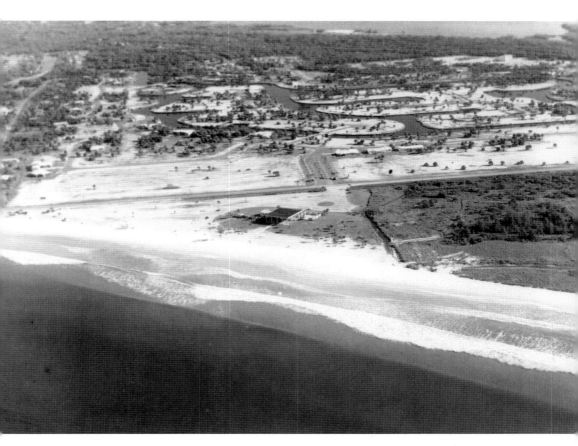

Siesta Key still maintained the ambiance of a tropical paradise. When this photo was taken in 1954, Siesta was reported to be "booming" because during the previous seven years it had grown to an estimated 500 permanent residents. But the beaches were not enjoyed by our black population. During the mid and later 50s, the country threatened to sell its three beaches and refund the $250,000 bond issue rather than integrate. The city temporarily closed a strip of beach along Ben Franklin Drive when blacks went there to swim. MacKinley Kantor threatened to write a column for national publication entitled "Sarasota Cheats Its Black Children" unless the problem was solved. In 1957, *The News* ran the headline, "Negro Minister Warns of New Black Invasion." Sarasota still had a long way to go. The pavilion, designed by Sarasota School of Architecture architect Tim Seibert opened in 1959. *Department of Historical Resources*

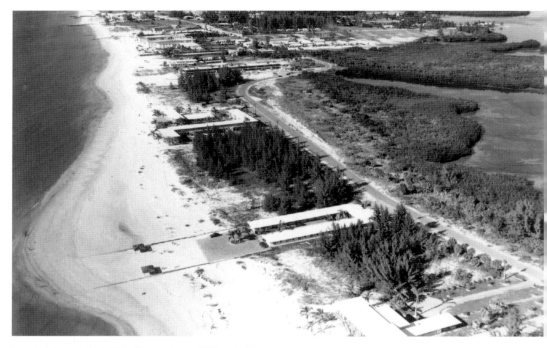

South Lido, early 1950s. *Department of Historical Resources*

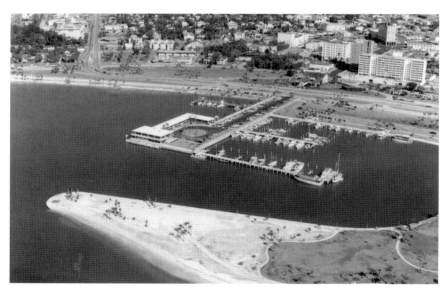

Recently completed Island Park juts into Sarasota Bay. By the time this shot was taken, Marina Jack had replaced city pier. *Sarasota County History Center*

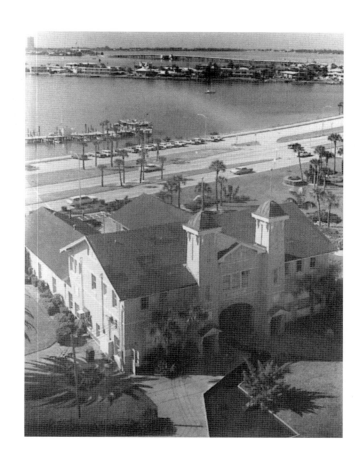

City Hall, mid-1960s. *Sarasota County History Center*

Sarasota Herald-Tribune

OCTOBER 16, 1959

ARVIDA ANNOUNCES BIRD KEY PLANS

Bird Key to Have 291 Waterfront Lots!

New Development Will Also Have 220 Off-Water Sites

Waterfront lots in Sarasota have long been in short supply. Sarasota Real Estate Brokers have long felt the need for such property, but up till now it has been practically unobtainable. With the recent purchase of Bird Key by Arvida, 291 lots will front waterways of the bay itself. According to John M. Weir, President of Arvida Realty Co., every waterfront lot will have its own seawall built-in. From here the residents can moor his own boat and within minutes cruise to the gulf and the best deep sea fishing on the gulf coast. The tidal flow assures good clear water, a fact that should make seawall fishing highly productive.

One of the big attractions of the bay front homesites will be the gorgeous view of the lights of the nearby Sarasota mainland. The serenity of relaxing on one's own patio and watching the moon rise over Sarasota Bay at twilight is a rewarding experience and those who secure such property are fortunate indeed.

Ringling Estate Becomes Site of Bird Key Yacht Club

Bird Key Yacht Club

There was a time when the lovely old mansion of Henry Ringling was the scene of many a festive occasion for the society set and the notables of the world. In a beautiful setting of lavishly landscaped and smooth manicured lawns, surrounded by the sylvan beauty of pines and palms, the Ringling Mansion stood majestically along on this island Paradise of Bird Key.

This is as many years ago and the old mansion, long in disuse, will soon be replaced by the beautiful Bird Key Yacht Club. This will be the social gathering place of Bird Key residents and their guests.

A recreational area will provide a swimming pool, tennis and other sports facilities. Mooring and marina facilities will be available for members. While final details have not yet been completed, it is expected that the Bird Key Yacht Club will be one of the finest on Florida's West Coast.

It will be built at the expense of the developers.

The architectural design of the Yacht Club is Bahamian Colonial containing approximately 11,000 square feet of floor space and featuring dining room facilities to serve 150 persons.

In addition to the main dining room, the Club includes an attractive cocktail lounge, a men's grille and card room, a ladies' card room, a lounge and men's and ladies' locker rooms convenient to the recreational area. A spacious porch and terrace overlook the marina and Sarasota Bay.

Site-planning has provided excellent locations for construction of swimming pool and tennis facilities.

Werner Kannenberg and Edgar C. Hasebuth have architectural-engineering degrees and have been actively engaged in the practice of architecture since 1928. Both are registered architects in the states of Illinois and Florida.

Since combining their Sarasota offices in 1946 they have accomplished the following structural designs: Siesta Key Hotel, Emerald Shores, Royal Palm and Seminole Motels, Sarasota Yacht Club, Palmer First National Bank and Trust Co., First Federal of Sarasota, Citizens Bank of Sarasota. In addition, they have designed 11 churches, several offices and over 200 prominent residences in the Sarasota area.

Mr. Hasebuth is the Club's architect.

Present at last night's meeting was Milton N. Weir, President of Arvida Corporation. Mr. Weir's experience as Senior Partner of M. N. Weir & Sons, Inc., has given him a keen insight on the Florida Real Estate market. He predicts that Bird Key will rank high among Florida's finest residential developments.

Mr. Milton N. Nelsom Weir, President and Member of the Board of Arvida Corporation (of which Arvida Realty Co. is a subsidiary), together with his son, John, spearheaded the purchase of the Ringling properties, including the present Bird Key Development.

Prior to forming the Arvida Corporation in 1958, Mr. Weir played a leading role in Florida real estate and banking from 1949.

As Chairman of the Board of M. N. Weir & Sons, Inc., realtors; senior partner in Milton N. Weir & Sons, investors and contractors.

As President of Weir-Plaza which developed the Plaza Center, Fort Lauderdale's second largest suburban shopping center.

An original developer of the multi-million-dollar Pompano Surf Club, a cooperative development of 40 homes and 32 apartments—and the equally luxurious Palm Club, containing 99 homes. Both developments are in Pompano Beach.

As founder of three Florida banks—the Delray Beach National Bank, the First National Bank of Pompano Beach and Fidelity National Bank of West Fort Lauderdale.

Mr. Weir was the original developer of the West Side Airlines Terminal in New York City in 1951.

In 1933, Mr. Weir joined the Gulf Oil Corp., forming that company's first New York real estate department. He became Assistant to late Vice President of Gulf and later President of one of Gulf's subsidiary corporations. He retired from the company in 1949.

After attending Colgate University, he began his business career in his early twenties as a partner in a construction firm in Binghamton, New York. He built hundreds of homes, apartment houses, stores and other structures.

Mr. Weir is married and the father of three sons—John, who is Vice President and General Manager of Arvida Corporation; Milton, Jr., President of M. N. Weir & Sons, Inc., realtors; and William, President of Weir-Contractors, builder for Weir enterprises.

Mr. Weir is a member of the Metropolitan Club of New York, the Bankers Club of New York, the Wings Club, the Admirals Club and the Miami Club of Miami, Florida.

Brokers Pack Auditorium for Presentation Meeting!!

Crowd in Festive Mood as Arvida Unveils Plans

A crowd estimated at well over a thousand registered real estate brokers and their salesmen were on hand at the Sarasota Civic Auditorium last night to hear Arvida Realty's plans for Bird Key. Purchased by Arvida Corporation a few months ago from the John Ringling Interests, Bird Key is ideally located in Sarasota Bay just off Ringling Causeway.

Arvida Realty plans to develop 511 homesites and, in addition, build a Yacht Club and Basin. This news was greeted with tremendous enthusiasm by the brokers, who have long been "starved" for available good waterfront homesites. The Bird Key development includes 291 lots that front either Sarasota Bay or one of the several planned waterways.

The meeting opened with a welcome and short introduction to Bird Key by John M. Weir, Vice President and General Manager of Arvida. He then, by arrangement, talked with Dave Garroway (MC of NBC-TV's "Today") on the telephone from New York.

Dave Garroway, whose "Today" show will help promote Bird Key on TV network.

Garroway, who will plug Bird Key on his network show, then told the audience of the detailed plans for Bird Key, how it will be advertised on TV, radio, and in newspapers and magazines. He went on to tell them of the various sales aids that are being prepared and of the opportunities to brokers and their salesmen in promoting Bird Key, the first development of its kind in Sarasota.

Following Garroway's talk, which was illustrated by color slides, John Weir took the stage and elaborated on Company policy and further details of Arvida's plans for the waterways, the yacht club, the roads and entrance gates and other attractions.

The meeting buzzed with enthusiasm. Many brokers were heard to say this is the greatest thing that has happened in Sarasota in years. Evidently, demands for choice waterfront homesites have long exceeded the supply and a brisk market is anticipated.

Following the meeting refreshments were served and Sarasota has seldom seen its equal in showmanship. Four separate refreshment bars were kept busy. All kinds of tempting, tasty snacks were served, buffet style. Beauty queens, pushing fancily decorated wheelbarrows, circulated among the crowd. The wheelbarrows were packed with shaved ice, shrimp on forks surrounding a bowl of shrimp sauce. Tasty dishes such as this, were, needless to say, most popular.

Elaborate Gates to Mark Bird Key Entrance

The natural seclusion and serenity of Bird Key with its tropic isle atmosphere of rustling palms, exotic birds and the gentle waters of the bay, will be further enhanced by elaborate gates at the entranceway, just off Ringling Boulevard. Uniformed attendants at the gates will further assure privacy to Bird Key, throughout the day and night.

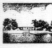

Connecting Sarasota's mainland with Bird Key is the scenic Ringling Causeway and Boulevard. Bird Key is just a few minutes' drive from the modern shopping center and the Arvida Realty Company's office on St. Armand's Circle.

Soon residents of Bird Key will be able to dock their boats at their own seawall or the nearby Yacht Club. Homes such as this will transform Bird Key to one of the picture spots of Florida's west coast.

The entrance-way to Bird Key will feature gates similar to those at Arvida Realty's Royal Palm Yacht and Country Club development at Boca Raton. (shown above)

Sarasota's emergence as a renowned winter resort was signaled by the building of Mira Mar Apartments and Hotel during the Roaring 20s. Of equal importance to today's modern city was the watershed announcement at the end of 1959 that Arvida would develop Bird Key and later Longboat Key. The original price list for property on Bird Key ranged from a low of $9,000 to a high of $32,000. There were 291 waterfront lots. Arvida was formed in 1958 by Arthur Vining Davis, then 91, and at that time one of America's five wealthiest citizens. Arvida is derived from the first two letters of each of his names. *Sarasota County History Center*

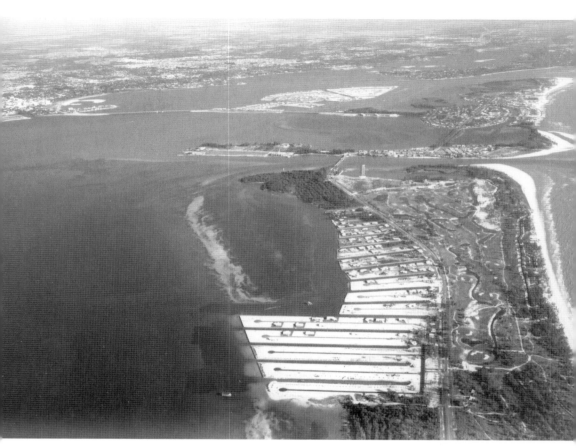

This photo, taken about 1964, shows Arvida construction underway on Longboat Key. Bird Key is completely dredged, and Island Park, the white speck at the upper left, nearly completed. The west side of Longboat, in this picture, is yet to be developed and gives an idea of the beaches that old timers reminisce about. *Sarasota County History Center*

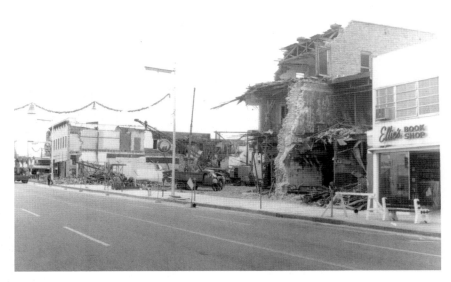

By 1964, downtown was no longer the center of Sarasota's world. The *Sarasota Herald* announced, "Landmarks Going," as these buildings on the south side of lower Main Street were razed to make way for the 150-space Central Parking Plaza; among them, the Downey Building and Badger's Drugs. In 1971 plans were underway to build the twelve-story Coast Federal Savings and Loan Building on this site. *Sarasota County History Center*

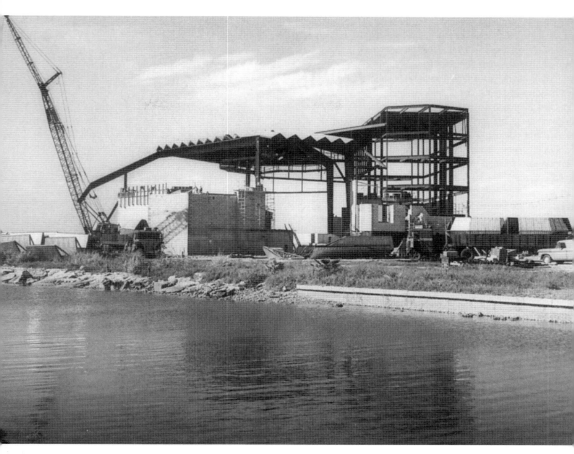

Construction is underway in this 1969 photo of Van Wezel Performing Arts Hall. Designed by William Wesley Peters, head of Frank Lloyd Wright's famous Taliesin Associated Design Firm, Peters said of the building, "This form of the present design has been influenced by [the] simple but complex world of the seashell, the mollusk, the conch, the scallop, and the sea urchin." The idea for a city-owned performing arts hall was first put forward by Allied Arts Council President Rita Kip. She aroused the interest of Mayor David Cohen, who was a noted local musician and concertmaster of the Florida West Coast Symphony. In 1964 a $1.35 million bond issue was voter approved. However, more money was needed and the city turned to the Lewis and Eugenia Van Wezel Foundation. They agreed to donate $400,000 if the hall was named in honor of the Van Wezels. Opening night for the first production—*Fiddler on the Roof*—was January 5, 1970. *Ilene Denton*

Looking east from the Gulf of Mexico. At the upper right, construction is underway on Bird Key. In 1966 Sarasota's tallest building, Plymouth Harbor, would open with 25 stories. It was designed by Frank Folsom Smith. *Department of Historical Resources*

Other books by the author:

Quintessential Sarasota, Stories and Pictures from the 1920s to the 1950s
Sarasota, Then And Now
The Lido Casino, Lost Treasure On The Beach
Come On Down, Pitching Paradise During The Roaring 20s
A Passion for Plants, Marie Selby Botanical Gardens
SARASOTA
Quintessential Sarasota, Stories and Pictures from the 1890s to the 1950s
Vol. II